LEGENDARY LOCALS

OF

ARLINGTON

MASSACHUSETTS

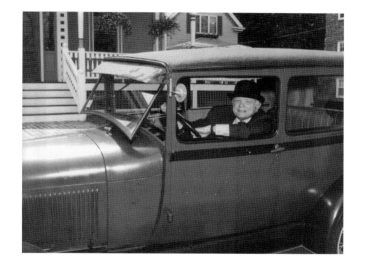

D1547778

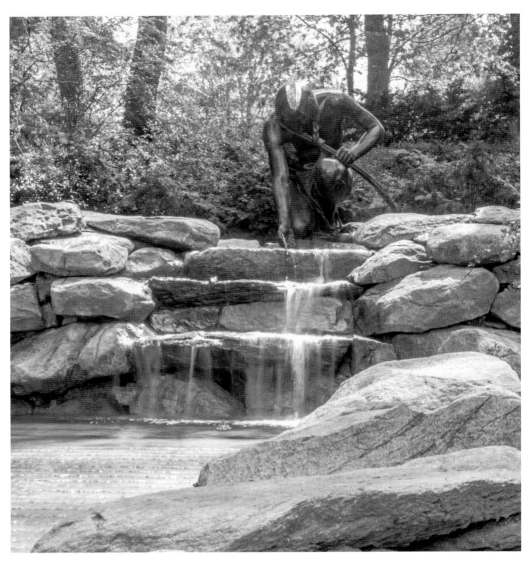

Menotomy Indian Hunter by Cyrus E. Dallin
The sculpture was commissioned by the Robbins family to honor Winfield Robbins. The work portrays one of the community's first inhabitants and is in a wooded setting between Robbins Memorial Town Hall and the Robbins Library. (Courtesy of Joan Roman.)

Page 1: Harry Barber
Known for tooling around town in his 1929 Ford Model A, Barber was also renowned for his colorful hats—a bowler, fez, or skimmer. He drove cancer patients to their appointments and created and hosted a television show for senior citizens. He lived life with gusto and a passion for helping others. (Courtesy of Beatrice Barber.)

LEGENDARY LOCALS
OF

ARLINGTON
MASSACHUSETTS

BARBARA C. GOODMAN
AND MARJORIE HOWARD

LEGENDARY
LOCALS

Copyright © 2015 by Barbara C. Goodman and Marjorie Howard
ISBN 978-1-4671-0223-0

Legendary Locals is an imprint of Arcadia Publishing
Charleston, South Carolina

Printed in the United States of America

Library of Congress Control Number: 2015937654

For all general information, please contact Arcadia Publishing:
Telephone 843-853-2070
Fax 843-853-0044
E-mail sales@arcadiapublishing.com
For customer service and orders:
Toll-Free 1-888-313-2665

Visit us on the Internet at www.arcadiapublishing.com

Dedication
To the people of Arlington

On the Front Cover: clockwise from top left:
Johnny Kelley, Boston Marathon runner (Courtesy of the Arlington Historical Society; see page 120),
Mark Twain and John Townsend Trowbridge, writers (Courtesy of the Arlington Historical Society;
see page 48), Susan Hilferty, Tony-winning costume designer (Courtesy of Susan Hilferty; see page 52),
Oakes Plimpton, founder of the Boston Area Gleaners (Photograph by Joey Walker; see page 20), Mark
Harvey (Photograph by Kate Matson; see page 54), Howard Sessler, airman who flew with the Doolittle
Raiders (Courtesy of Barbi Ennis Connolly; see page 77), Vance Gilbert, singer/songwriter (Photograph
by Chris Parent, see page 59), Gwenyth Hooper, founder of Arlington Children's Center (Photograph
by Bob Sprague; see page 27), John Mirak, car dealer and philanthropist, and manager Lew Warsky
(Courtesy of Bob Mirak; see pages 109).

On the Back Cover: From left to right:
Cyrus E. Dallin, sculptor (Courtesy of the Robbins Library; see page 43), Hurd family baseball team
(Courtesy of Frank Hurd; see page 72).

CONTENTS

ACKNOWLEDGMENTS

This book was supported in part by a grant from the Arlington Cultural Council, a local agency supported by the Massachusetts Cultural Council, a state agency.

The authors gratefully acknowledge Bob Sprague and Ron Sender for their support and encouragement. They also wish to thank Richard A. Duffy; the Arlington Historical Society; Doreen Stevens, Grace Dingee, and Ed Gordon of the Old Schwamb Mill Trustees; Sara Lundberg and Pamela Meister of the Arlington Historical Society; Ellen Wendruff, local history librarian; Rose Udics; Evelyn Smith DeMille, administrator of the Sanborn Foundation; Marie Krepelka, administrator for the board of selectmen; Timothy Ruggere, principal of Ottoson Middle School; Geraldine Tremblay and James McGough of the Dallin Museum; George Gross, Matthews Museum, Union, Maine; Bill Murphy of the Council on Aging; Joan Roman, photographer; Bill Teschek, Lane Memorial Library, Hampton, New Hampshire; Nancy A. White, photographer; Paul Hogman, captain of the Menotomy Minutemen; William and Carol Mahoney; Dick Howe; Margie and Joey Walker; yourarlington.com; and the *Arlington Advocate*; and, for their patience, Emily and Sofia Sprague.

INTRODUCTION

Arlington has a rich history, from the time when Native Americans lived along the Alewife Brook and the Mystic River to its role in the American Revolution to the current day, when it has become a desirable place to live thanks to its good schools, parks, and proximity to Boston. It is a lively and energetic community, with residents who are passionate about causes and politics and quickly pitch in to help someone in need.

In some ways, it is still a small town, with residents fiercely attached to their neighborhoods. People enjoy sledding at Robbins Farm and fishing and skating at Spy Pond or Menotomy Rocks. Yet Arlington offers the sophistication of a small city, with music, dance, and drama as well as a variety of restaurants featuring not only pizza but food from India, Thailand, Mexico, and Korea.

The town has had several incarnations. In the 19th century, it was a bustling center of industry when ice from Spy Pond was packed and shipped in sawdust to the Caribbean. At one time, there were as many as 60 farms in town growing lettuce, cabbages, cucumbers, and beets, with celery as a major crop. The Mill Brook provided water power for industries.

While Massachusetts Avenue, which bisects Arlington, unites the town, there are distinct neighborhoods with their own characteristics. The multifamily homes in East Arlington, with its ease of transportation to the MBTA subway, give way to single-family homes in the heights and a more suburban feel adjacent to Winchester.

Massachusetts Avenue is a valley with hills on either side. The hills make for great sledding, with Robbins Farm offering steep rides for daredevils. Those who simply want to watch sledding can enjoy the panoramic view of Boston. On the Fourth of July, residents spread blankets on the hillside to see the fireworks from Boston's Esplanade.

The town has had three names, with the first one dating back to the time of Native Americans. The Native American word for swift running water is Menotomy, the town's first name. Menotomy was founded in 1635, and the town's running water enticed Capt. George Cooke to build a mill. Farmers came from miles away to grind their grain. Initially, Menotomy was part of Cambridge, or more specifically, part of the Church of Cambridge. The church played a major role in civic life and had authority over almost all matters except those of a military nature. In 1725, the residents of Menotomy petitioned the church, seeking their own congregation. Their request was denied, as were their next attempts in 1728 and in June 1732. Later that year, Cambridge relented and granted Menotomy permission to build its own church and become the second precinct (parish) of Cambridge.

Farmers from the west and northwest passing through Menotomy on their way to Cambridge, Boston, and Charlestown needed a place to stop and enjoy refreshments. They soon had their choice: the Black Horse Tavern, at what is now 333 Massachusetts Avenue; Cooper Tavern, at Massachusetts Avenue and Medford Street; and Tufts Tavern on Prentiss Street. Here was where local militia met to plan their upcoming battles with the British soldiers. Legend has it that the three stars on the Menotomy Minutemen's banner represents these three taverns.

History unfolded in the center of town on April 19, 1776. Though Ralph Waldo Emerson credits Concord with the "shot heard round the world," the bloodiest battle of the day occurred right on Massachusetts Avenue in Arlington. By any criteria, including fierceness of battle and number of men killed or injured, no other place on the British retreat was more significant. On that day, as the British marched back to Boston, a running battle took place. The British rushed the Jason Russell House, killing 11 people. Among the dead was Russell himself. The house now operates as a museum, and bullet holes from that day are still visible.

In 1807, after 65 years and two failed attempts, the general court allowed Menotomy, with a population of about 900, to become a separate town called West Cambridge. By 1840, the population was almost 1,400, and Arlington was starting to take on the flavor of a suburb, with wealthy merchants living in town and working in Boston.

On May 27, 1867, town officials voted to change the name of West Cambridge to Arlington to honor the dead in Arlington National Cemetery. The town celebrated with a brass band, 100-gun salute, and ringing of church bells. A larger celebration followed in June with a regatta, banquet, parades, and a grand procession of dignitaries from across the state.

Today, the town is a mix of families, graduate students, academics, and people simply attracted by the rich resources Arlington has to offer. Citizen activists have maintained a forward-looking community, with a strong network of support for town resources. They have founded groups to support arts programs, the schools, parks, and the libraries. And their concern and care extends to its citizens. When an illness or other misfortune strikes, Arlington residents are there to help.

Many of its citizens have bravely served their country, among them Francis M. Donnelly, who won a Purple Heart, and the Carroll family, seven of whom were in the armed forces. Eugene McGurl and Howard Sessler were among the 80 Doolittle Raiders who bombed Japan in World War II. Seventy-three years later, Arlington resident Chris Costello was chosen to design the congressional medal honoring the dangerous raid.

Two institutions reflect the energy and involvement of its citizens. Town meeting is the foundation of Arlington's government, where representatives from 21 precincts animatedly debate issues ranging from budgets to bicycles. "The List," as the Arlington e-mail list is known, was started in 1998 by Betsy Schwartz when she passed around a sign-up sheet at a local park. Today there are more than 6,000 members engaging in lively discussions ranging from politics, restaurants, and schools to questions about home repair. It has been managed since 2007 by Richard Damon.

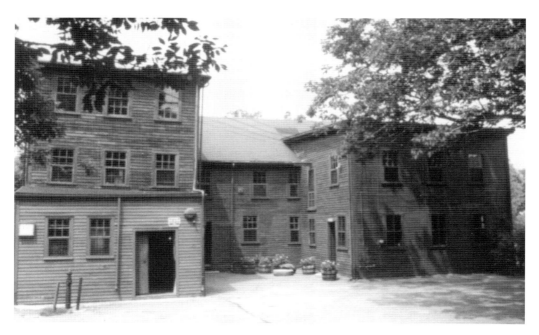

Old Schwamb Mill
The Old Schwamb Mill is where for more than 300 years entrepreneurs have harnessed the water power of the Mill Brook. It is now also a museum where visitors can see how hand-turned oval frames are made on a 19th-century lathe. (Courtesy of the Old Schwamb Mill.)

CHAPTER ONE

Community Service

There are many people who say "someone has got to do something;" the people in this chapter have decided that they are that someone.

In this chapter, one will learn about people who have reached out to those in need. They visit the sick, support victims of domestic violence, and make sure that children do not come to school hungry. Some have dedicated their lives to guiding Arlington youth or making sure elders are well cared for. These are the people who not only invest their time, they open their hearts in order to ease the burdens of others.

Included in this section are people whose dedication and persistence helped preserve Arlington's historic places. They raised or donated money, established museums, wrote books, gave lectures, and provided tours.

Arlington is an old town. It is fully developed, with little open space. Close to Boston, public transportation, and Route 2, it is an obvious choice of developers who want to build on the few open areas or raze homes and replace them with new construction. One will come to know a woman who, over four decades, has fought tirelessly to protect open spaces and a husband-and-wife team who has advocated at all levels of government to protect historic buildings.

The chapter describes a farmer who, despite the wishes of his wife and the appeal of money from developers, donated his lands for a playground and the people who have volunteered to maintain and enhance this park.

Discussing, debating, and deciding are never easy tasks. They are especially burdensome when 252 people come together in town meeting to make important decisions for the town in which they live. Yet every year, 252 people participate in the messy and frustrating task of making democracy work.

In 1910, Ida Robbins wrote to a young friend upon her graduation: "Be good and be good for something—the world has great need for positive goodness." Certainly these words are just as true today as they were then.

Capt. Samuel Whittemore (1694–1793)
On April 19, 1776, as the British retreated down Massachusetts Avenue from Lexington, 80-year-old Whittemore hid behind a stone wall. Armed with a gun and a pistol, he killed three Redcoats. Enemy troops shot him in the face, bayonetted him multiple times, and left him for dead. He lived for 18 more years and (as some have claimed) was able to see his 185 progeny live free of British rule. (Photograph by Barbara C. Goodman.)

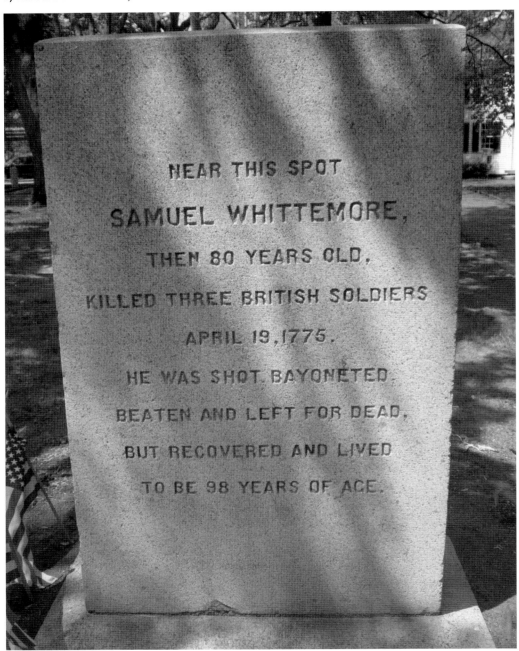

NEAR THIS SPOT

SAMUEL WHITTEMORE,

THEN 80 YEARS OLD,

KILLED THREE BRITISH SOLDIERS

APRIL 19, 1775.

HE WAS SHOT BAYONETED,

BEATEN AND LEFT FOR DEAD,

BUT RECOVERED AND LIVED

TO BE 98 YEARS OF AGE.

Jason Russell (1716–1775)

The bloodiest battle of the first day of the American Revolution took place at Jason Russell's house. On April 19, 1775, the British retreated from Concord, burning homes along their route. Russell, wanting to save his home, pleaded for help. Minutemen troops gathered on his front lawn, and a battle ensued. Jason Russell was killed at his doorstep as the battle continued into his house. Additionally, 11 Colonists and two Redcoats died here. (Courtesy of the Arlington Historical Society.)

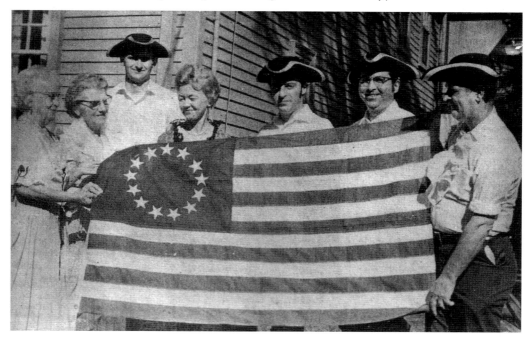

The Menotomy Minutemen, April 6, 1971

Two centuries after the formation of the original committee of safety, the selectmen proclaimed the newly created Menotomy Minutemen as the official militia of the town of Arlington. The flag is being presented by the Daughters of the American Revolution to four of the founding members, from left to right, Paul Hogman, Mark Kahan, Stanley Rezendes, and Lt. Frederick Sennott. (Courtesy of the *Arlington Advocate*, June 17, 1971.)

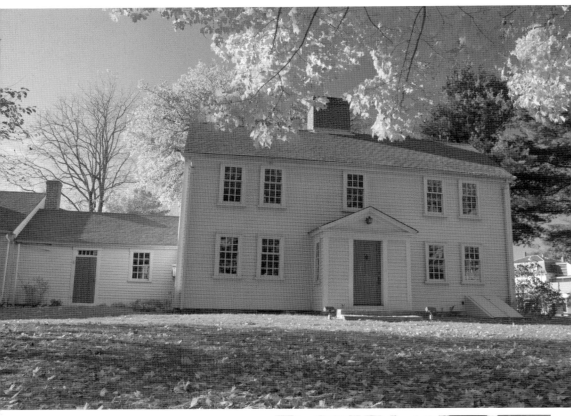

George Abbot Smith (1862–1953) and Elizabeth Abbot Smith (1900–1976)

George and his daughter Elizabeth were dedicated to the preservation of Arlington's history. George purchased the land at the corner of Massachusetts Avenue and Mill Street, demolished the modern buildings there, and gave the land to the historical society as an appropriate place for the Jason Russell House (above). In memory of her father and grandfather (Rev. Samuel Abbot Smith), Elizabeth donated money to restore the Jason Russell House and expand it to include a museum and a library. Dedicated in 1981, the Smith Museum offers tours of the Jason Russell House and exhibits the society's collection of artifacts and other items. (Above, courtesy of Joan Roman; right, courtesy of the Arlington Historical Society.)

Augustin Thompson (1835–1903) and Francis Thompson (1864–1939)
Each year, about 100 Arlington High School graduates receive a Francis E. Thompson Scholarship in amounts of $200 to $2,000. In 1904, Thompson took over the Moxie Company from his father, Augustin, who had invented a cure-all elixir called Moxie Nerve Food. Francis carbonated the drink and marketed it as a refreshing beverage. Moxie became the most popular soda in the United States, and the word "moxie" became part of the American vocabulary, meaning brave or gutsy. Today, Moxie is still sold in many supermarkets. When he died, Thompson left the town $50,000 for scholarships, and Arlington named the Thompson School in his honor. (All, courtesy of the Matthews Museum of Maine Heritage.)

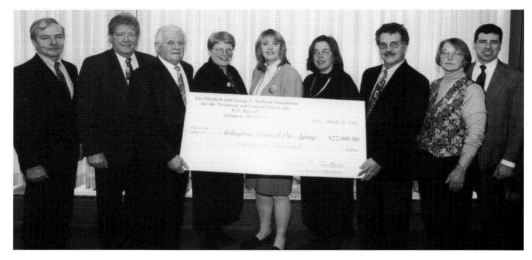

The Elizabeth and George L. Sanborn Foundation for the Treatment and Cure of Cancer

The foundation was established in 1998 through the bequest of the late Arlington resident George L. Sanborn. The gift was made in memory of his wife, Elizabeth, and was also in his honor. Elizabeth Sanborn died of cancer in Arlington in 1931.

The foundation awards grants to residents who have cancer to help pay for services not covered by insurance, including medical bills, medication, adaptive equipment, and hospice care. The foundation also funds prevention programs and research.

The Sanborn foundation has awarded grants to the Arlington Council on Aging to provide transportation to medical appointments for Arlingtonians of any age. It has also funded antismoking programs in schools and smoking cessation sessions in the community. Members of the original board are, from left to right, Kevin Wall, Donald Mahoney, George "Brud" Faulkner, Judith Spross, Victoria Palmer-Erbs, Debra Kaden, John Jolpe (executive director, Arlington Council on Aging), Evelyn Smith-DeMille (executive administrator, Sanborn Foundation), and Robert Pasciuto (Cambridge Trust Company). Not pictured are Michael Foley, Jacqueline Keshian, and John Worden.

Below, John Jolpe (right) accepts a check from board member Brud Faulkner. (Both, courtesy of the Sanborn Foundation.)

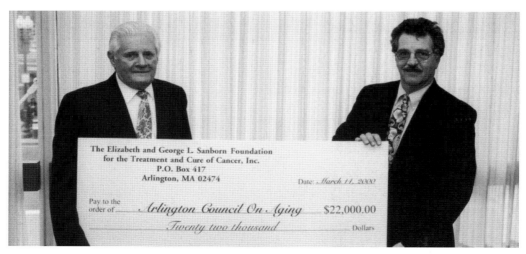

Nathan Robbins (1866–1960)

Robbins owned a 12-acre farm that ran along Eastern Avenue abutting his home at the top of Grandview Avenue. The house offered an unobstructed view of Boston. Robbins grew a variety of crops, specializing in corn, and like his grandfather and namesake, he also raised poultry.

Nathan and his wife, May, were known for not getting along. Though they lived in the same house, they did not speak to each other for 20 years or more. They even ate dinner at separate tables. One of their differences was that Nathan loved children and enjoyed having them help him around the farm. May was known to shoo them away.

After his retirement in 1940, Nathan wanted to give his farm to the town for a playground. May wanted to sell it to developers and filed a petition with the Middlesex Superior Court to block the donation. The Heights Tower Association intervened and convinced the town meeting to take the farm and house by eminent domain for the purpose of establishing a park and playground that today is known as Robbins Farm.

In 1942, the Heights Tower Association held the first annual field day in the park. In addition, the produce from 46 wartime victory gardens was exhibited and prizes given. Now neighbors plant cooperative community gardens each spring.

Robins Farm Park is currently used extensively for birding, dog walking, sledding, and kite flying. The playground is almost always full of children. The expansive view of the Boston skyline makes it an ideal spot to watch the Fourth of July fireworks celebration over Boston Harbor. (Courtesy of the Arlington Historical Society.)

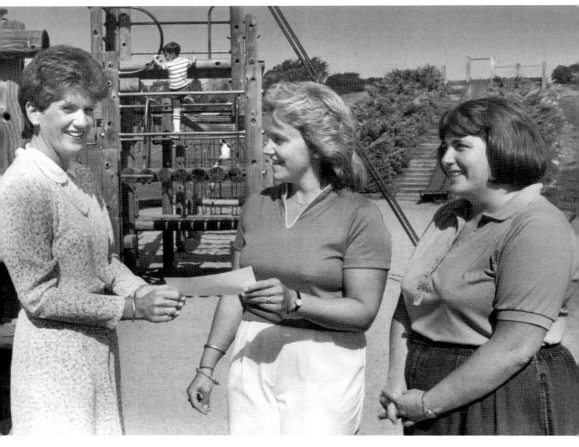

Susan Orr

When Sue Orr (center) brought her eight-year-old son to the Robbins playground she was dismayed to find that most of the apparatus was damaged and that the poles that held up the equipment were rotten and bug-infected. Knowing that the town did not have the funds to fix this play area, she decided that she would take on the project of raising money to rebuild it. In September 1988, Orr approached the town's parks and recreation department with a proposal to raise $65,000. It was very skeptical of her ambitious plan. One month later, after organizing a committee, forming a nonprofit corporation, and developing a fundraising plan, Orr returned to the department and won its approval.

On April 28, 1990, the old park was demolished. For the next three weeks, Andrew Fischer, a local contractor, coordinated a construction crew of 150 volunteers. Local businesses donated food and beverages. The Arlington Department of Public Works supplied equipment and its trained staff. Boston Edison provided night lighting, and members of the civil defense and the auxiliary fire department stayed up all night to secure the site.

On May 20, 1990, Sue Orr dedicated the playground to the children of Arlington and presented the park as a gift to the town of Arlington along with additional funds to help with maintenance. One woman's dream became a community endeavor and a park for all to enjoy. (Courtesy of Sue Orr.)

Roland "Roly" Chaput

Some people retire and do volunteer work for a few hours a week. Chaput turned his retirement into a fulltime unpaid labor of love for his town.

Since 1994, he has been a member of the advisory council for Brackett, his neighborhood school. One of his proudest accomplishments is organizing a group of seven or eight retirees who, on a weekly basis, read with kindergarten children who need extra help.

Roly was also one of the founders of the Friends of the Robbins Farm Park. This 350-member organization "promotes the beautification, restoration and improvement" of the park and its playground and sports fields. Roly helps organize several annual park events, including a yearly clean-up, a field day, a Fourth of July celebration, a community garden, and an outdoor concert series. Friends of the Robbins Park have raised over $50,000 to replace a long slide that continues to be a favorite of the children.

Roly led the effort to retrieve the Robbins family's Labrador mastiff statue that had gone missing for 65 years. The four-foot-long cast-iron statue once stood guarding the house on Eastern Avenue. Kids played on it as their parents took photographs. When the house was demolished in 1950, the dog disappeared. Roly and the Friends of Robbins Farm raised over $20,000 to commission a replica so that the dog can be returned to its place on the hill.

Roly has always had an interest in art, and he is currently a member of the Board of the Dallin Art Museum, volunteering one day a week to give tours to visitors.

Roly has been a town meeting member for 43 years and is a member of the tourism and economic development committee. He is a regular volunteer at the visitor center that he helped create. (Photograph by Barbara C. Goodman.)

252 Town Meeting Members

Every spring, 252 Arlingtonians meet to debate matters that have an impact on the town. These are town meeting members—12 elected from each of 21 precincts—who make up town meeting, Arlington's legislative body. Twice weekly, sometimes for weeks and often for months, these citizens dedicate their time and energy to make Arlington a better place to live. They vote on multimillion-dollar town and school budgets, zoning bylaws, parking regulations, town official salaries, union contracts, and myriad other issues large and small. Members question town officials, voice their concerns, and initiate change. It is democracy in action. Though Arlington is large enough to be a city with a mayor and aldermen, residents have chosen to keep it a town in order to preserve the town meeting form of government that maximizes citizen participation. (Above, courtesy of the Arlington Historical Society; below, photograph by Barbara C. Goodman.)

John Quincy Adams Brackett, 38th Governor of Massachusetts
In 1886, when Lieutenant Governor Brackett was living in Arlington, he voiced strong opposition to a local referendum that would have permitted the town to grant liquor licenses. The referendum was defeated, and Arlington remained virtually a dry town until 1994. It is believed that Brackett's strong stand and his oratory skills helped elect him governor. Brackett Elementary School is named in his honor. (Courtesy of the Robbins Library.)

Sheri Baron and Roger Barnaby
After many others had failed, Sheri Baron and Roger Barnaby led a successful referendum campaign to allow restaurants to serve wine and beer. With the exception of two large-capacity establishments and private clubs, Arlington had been virtually a dry town for about a century. Their 1994 campaign allowing smaller restaurants to serve wine and beer won 70 percent of the vote. Since then, the number of restaurants has grown from just a handful to 73. (Photograph by Barbara C. Goodman.)

Oakes Plimpton

Oakes Plimpton worked for the Conservation Law Foundation and the Nature Conservancy before deciding he would rather be a farmer. He describes himself as a member of the back-to-the-land movement, and since the 1970s, Plimpton has worked with local community farms and helped found and manage Arlington's farmers' market. He organized the market after Pat Jones, a resident of Winslow Towers, suggested the idea, thinking the Russell Commons parking lot across the way would be a good location. Plimpton had worked with a similar market in Somerville and knew a lot of area farmers. He reached out to the farmers and vendors and was instrumental in the market's formation. In 2004, he founded the Boston Area Gleaners, which sends volunteer crews to farms throughout eastern Massachusetts to harvest what farmers cannot use from their fields. Since its founding, the Gleaners have delivered more than one million pounds of fresh local produce to food pantries and shelters. In 2014, the Arlington Food Pantry alone received 10,665 pounds of food. Plimpton has also written numerous books on local topics, including a history of Robbins Farm and another about farmers who sell their produce at the Arlington farmers' market. Plimpton comes from a distinguished family. One of his ancestors, John Plympton, arrived in Roxbury, Massachusetts, in 1630. Among his family members are a UN diplomat and a noted botanist, for whom he is named. In addition, his brother George founded the *Paris Review*. Oakes Plimpton is a well-recognized figure around town and often contributes comments to the Arlington e-mail list about his adventures, including skating on local ponds. He remains interested in natural history, in particular bird-watching, and was one of the cofounders of the Menotomy Bird Club in Arlington. (Photograph by Joey Walker.)

Glenn Koenig

Glenn Koenig is a self-taught videographer who was instrumental in the formation of Arlington Community Media, Inc. (ACMI). He is a longtime town meeting member who, for 20 years, was host and producer of election-night television coverage from town hall. Koenig's conversational style made listeners feel he was in their living rooms, delivering results and talking about turnout and candidates in a casual manner.

Koenig was involved in the early days of public-access television in Arlington, which began in 1980, producing numerous programs. By 2003, it became clear the town needed to form its own cable corporation, and Koenig organized a meeting to discuss incorporating. He was elected the first president. The founding members were Kathy Colwell, John Leone, John Clements, Julie Kuhn, Paul Berg, and Barbara Costa.

Today, ACMI's main studio is in the former Dallin Library, but it has satellite production centers across from the high school and at the Ottoson Middle School. Residents can tune in to see anything from local news to coverage of Town Day to what is happening with the board of selectmen or school committee. ACMI offers numerous workshops on video production and digital filmmaking, including lighting, editing, and screenwriting. One workshop, called Pocket Filmmaking, teaches how to use a cell phone to make good videos. ACMI also hosts a community events bulletin board.

Koenig is no longer ACMI's president, but he has continued to produce programs directly for the cable channel as well as programs he produced independently to put on their channels. He has also produced candidate coverage sponsored by the League of Women Voters. In 2010, ACMI gave him the prestigious Executive Director's Award. (Courtesy of Glenn Koenig.)

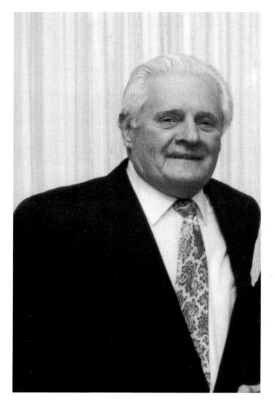

George "Brud" Faulkner (1928–2005)
Faulkner, a lifelong Arlington resident, dedicated his personal and professional life to the town's youth. A noted high school and college athlete, he was initially the physical education director of the Arlington Boys Club. In 1955, he became the executive director and served for 37 years. For his commitment to youth, Faulkner received numerous local and national awards. (Courtesy of the Sanborn Foundation.)

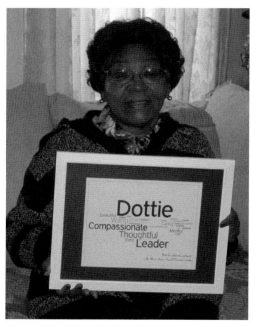

Dorothy "Dottie" Williams
Dottie Williams and her husband and four children were one of the first African American families welcomed into town by members of the fair housing committee. Williams quickly become involved in the community. She was president of Zonta, a professional women's service organization, for two years. As chair of the board of youth services for 12 years, Williams focused on issues of teenage pregnancy and domestic violence. Along with Nan and Wilson Henderson, Williams was a founding member of the Arlington African American Society. (Photograph by Barbara C. Goodman.)

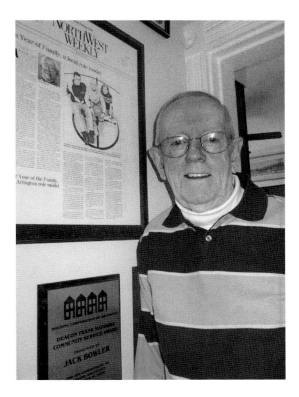

Jack Bowler

"When you want something done, ask Jack Bowler." That was the motto when he was a town employee, and it still holds true now, as he dedicates his retirement to helping others. Bowler was the office manager and assistant purchaser for the Arlington Department of Public Works. Before the advent of computers, Bowler used data and spreadsheets to increase efficiency and build public trust. He started a recycling program that saved money and then used the funds to improve the town's playgrounds. Bowler was town employee of the year in 1979 and 1990. His work became a model for other municipalities, and in 1980, he won the Massachusetts Outstanding Employee of the Year award from the Massachusetts Municipal Association.

Bowler retired in 1993 after 37 years of civic service, but he has not slowed down. He has been president of the Boys and Girls Club and active with St. Agnes Church, Sisters of St. Mary's Missionaries, Fidelity House, the United Way Success by Six programs, and the Arlington Food Pantry. In 1997, he initiated the "Year of the Family," a town-wide effort to be proactive in supporting families and children.

For 16 years, he raised funds for the women in First Step, a program for victims of domestic violence. When the women need money for schoolbooks, babysitters so they could attend the support group, food for their families, and clothes for job interviews, Jack Bowler reached out to residents and local businesses to meet their needs.

Bowler, guided by his deep faith and compassion for others, regularly visits the sick, leads religious services every Friday for nursing home residents, and has arranged monthly spaghetti dinners and dances for them at the local VFW.

He has earned many awards, including the Rotary Club's Person of the Year award (1995) for being "the living example of service before self;" the Arlington Chamber of Commerce's Citizen of the Year award (1997); the Housing Corporation Award (2008) for pioneering the Homeless Prevention Program; the Martin Luther King Award (2009); and the Bishop Cheverus Medal (2009) for his "selfless dedication and commitment and many contributions to advance Christ's mission." (Photograph by Barbara C. Goodman.)

Richard "Dick" Earl Smith (1930–2013)

Dick Smith was a political activist who, during the 50 years that he lived in Arlington, supported liberal causes and progressive candidates running at the local, state, and national levels. Smith was also a peace activist. He attended demonstrations with Veterans for Peace and was arrested several times. Dick and his wife, Ann, loved to travel—they explored 90 countries. Even as senior citizens, they preferred the rustic approach, often putting up a tent or staying in a youth hostel. When at home in Arlington, Dick was an active member of town meeting, serving on the town's Democratic Committee and as secretary to the Arlington Finance Committee. Dick founded the Nagaokakyo-Arlington Sister City Program and for 20 years led adult and student trips to Japan, promoting cross-cultural understanding and friendships. Below, Smith is pictured with a member of the Japanese delegation. (Both, courtesy of Ann Smith.)

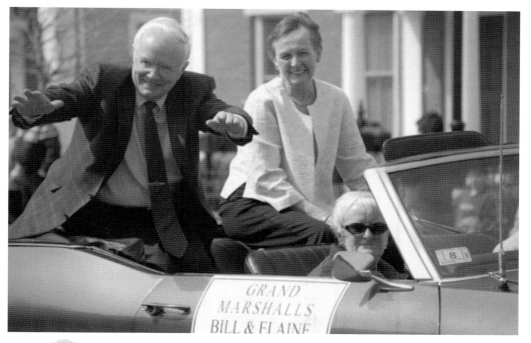

William "Bill" Shea (1935–2012)

Bill Shea, pictured above with his wife, Elaine, leaves a legacy of service to his community and to the less fortunate. He was a member of the planning board, the finance committee, and the human rights commission and spent 16 years as a member of the permanent town building committee. Bill was awarded the Martin Luther King Award in 1998, and in June 2013, he was posthumously awarded the Robbins Award "in recognition of significant contributions to the Town of Arlington in the area of Social, Cultural, Educational, Political or Philanthropic Service." He served on the Cambridge Board of the Salvation Army for 30 years. Bill was a tireless advocate for rebuilding Arlington's seven elementary schools. Just before he died, he was told that the library in the newly rebuilt Thompson School would be named for him. Bill Shea is pictured at left receiving the Salvation Army award. (Both, courtesy of Elaine Shea.)

Jane Howard

Jane Howard has been called the "consummate organizer" and will always be known as the prime mover behind Arlington Vision 2020, a collaboration of residents and town officials that revived local government after a decade of change due to the tax-cutting Proposition 2½. Howard grew up in Rhode Island and moved in 1964 to Arlington, where she raised four children and quickly became involved in volunteer activities. Vision 2020 is her most well-known accomplishment. The group has involved hundreds of people in its efforts to create a kind of master plan for the town, focusing on issues such as the environment, diversity, and education. The organization's goals became town bylaws, its annual survey helps continue to shape its efforts, and other communities have copied its approach. But Howard has been involved in numerous other organizations and programs. She has served with the Girl Scouts, volunteered as a guidance volunteer at the high school, and taught at St. Agnes School. She is involved in the Community Reads program, helps run the MIT Women's Chorale, and serves on the executive board of the MIT Women's League, where she chairs the lecture series on aging successfully. Her list of activities is two pages long. "When you have four children," says Howard, who worked as a nurse earlier in her life, "you tend to get involved." Howard says Arlington runs on a lot of volunteer energy. What she does not say is a lot of that energy continues to be hers. (Photograph by Joey Walker.)

Gwenyth "Gwen" Hooper

Gwenyth Hooper was the director of the Arlington Children's Center (ACC) for 31 years. As one of the founders of ACC, her first task was to obtain the necessary approvals from the various town boards in order to open the first fulltime childcare facility in Arlington. It was 1970, the feminist movement was emerging, and women with young children were eager to enter the workforce. The all-male board of selectmen and the board of health were more than displeased by this new movement. Hooper asked the selectmen for their approval to open a childcare facility. They refused. Hooper vividly recalls a member of the board pointing his finger at her and yelling, "Mrs. Hooper, women with children belong at home; and you, Mrs. Hooper, belong at home with your children."

After the meeting, a selectman went right up to her, wagged his finger in her face and said, "Mrs. Hooper, women shouldn't be taking jobs away from men." Gwen bit her tongue and smiled.

Several months and numerous legal letters later, the childcare center was approved.

It opened in January 1971 with a teacher, an aide, and nine children in attendance in the basement of the Trinity Baptist Church in Arlington. Hooper was committed to making the center a success. She worked five days a week, answering the telephone, giving tours to parents, covering for sick staff, and cleaning the toilets. She did this for two years without earning a penny.

During this time, she also took courses at Lesley College and earned a bachelor's degree in early childhood education.

In 1973, Hooper became the director of ACC. She did the work she loved: continually nurturing and improving the center. It became a model program, as professionals and politicians from across the state visited and asked her to speak at conferences. Even the selectman with the wagging finger sent his daughter to ACC and became one of Hooper's strongest cheerleaders.

When Gwen retired in 2004, ACC served 163 toddlers, offered preschoolers a fully accredited kindergarten program, and hosted an afterschool program for 55 students in grades one through five. (Photograph by Bob Sprague.)

Elaine Shea, Mary Deyst, and Claudette Lahaie

One day a week, 52 weeks a year, for 16 years, these three volunteers led a support group for victims of domestic violence. The group, called First Step, was founded in 1996 after representatives of the local police department and the Cambridge Probation Department spoke to the Arlington Board of Youth Services about the increased incidents of domestic violence. The board agreed to initiate a support group for victims.

Elaine Shea (left), a social worker with an interest in helping women find their voice, Claudette Lahaie (not pictured), a retired school nurse, and Mary Deyst (right), a compassionate citizen, volunteered to help these women in crisis.

Every week, 4 to 12 women, representative of every demographic group in town, met in a safe location. With the guidance of Shea, Lahaie, and Deyst, they shared their stories and supported each other. They drank tea from fancy china cups, because, as Elaine Shea says, "It is very hard to feel crummy about yourself when you are having tea in a fine tea cup." The group was funded by donations from various organizations and individuals. Several guardian angels have helped the women with rent, food cards, clothing, legal matters, dental work, and other personal and family needs.

In addition to running the support group, the trio worked to increase community awareness of domestic violence and the availability of help through First Step. They had booths at Town Day and spoke at clubs and churches.

In 2011, they decided to retire. A year later, with funding help from High Rock, a local church, the town hired a social worker to run the group.

Elaine Shea is continuing her work to promote community awareness about domestic violence. (Photograph by Howard Winkler.)

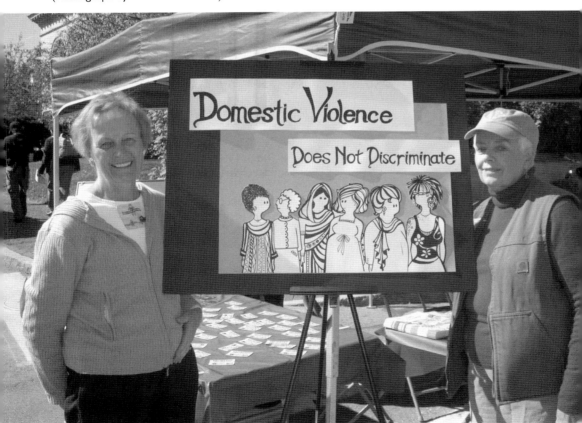

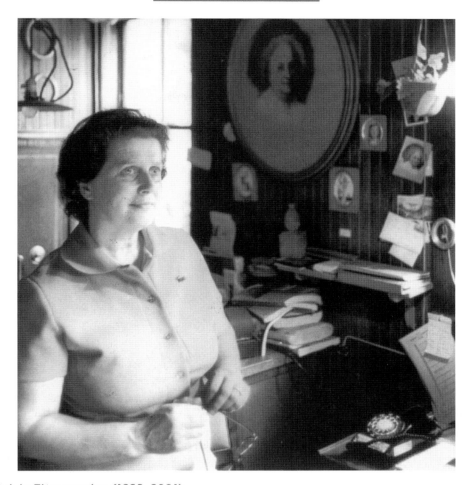

Patricia Fitzmaurice (1923–2001)
The 1969 pioneering grassroots movement to save the Old Schwamb Mill from demolition was led by Patricia C. Fitzmaurice, who served for 31 years as executive trustee of the Schwamb Mill Preservation Trust, which was formed in 1970.

Convinced of the mill's unique historical and educational value, Fitzmaurice was committed to preserving the entire environment of the mill to ensure a more accurate and complete historical account of the life and activities that took place there. The successful preservation of the mill's original buildings, tools, and 19th-century interior is due to her efforts. The result represents a unique view of the real life of the site, with all its practical and visual connections intact to tell its own story, undistorted by modern interpretation.

Throughout 30 years of financial struggles, grant-proposal writing, roof repairs, fundraising through wood and frame sales, her own donated 40-hour work weeks, and inventive resourcefulness, Fitzmaurice persevered and managed to keep the mill alive as a working industrial museum. The mill offers educational programs, guided tours, instructive exhibitions, and above all, the continuing business of making hand-turned frames on the well tended shaft- and pulley-driven 19th-century machinery.

Widely recognized in the field of preservation for her vision and infectious energy, Fitzmaurice was the recipient of the Commonwealth of Massachusetts Secretary of State's Preservation Award in 1988, and in 2000, she was honored with the Bay State Historical League's Ayer Award for her "outstanding contribution in preservation and the interpretation of Massachusetts history." (Courtesy of the Old Schwamb Mill.)

Richard A. Duffy

Duffy brings Arlington's history to life. While he writes books, give lectures, and supports museums, he also moves beyond these traditional methods to bring Arlington's past into the present. Duffy has worked with the Arlington Housing Authority to rehabilitate buildings for affordable housing, has given walking tours of Arlington's long-forgotten past, and has created permanent historical interpretations of parkland at the Arlington 360 Development.

Duffy's 100-part installment series in the *Arlington Advocate* on the history of Arlington's street names has made every neighborhood part of Arlington's history. His interest in history started when he was in elementary school, and he did his own independent research while in high school. Duffy has lived in Arlington most of his life and has restored two architecturally and historically significant homes, one of which was featured in the winter 2014 season of the PBS series *This Old House*.

He has served several terms on the Arlington Historical Commission, including six years as cochairman, has been an officer and trustee of the Arlington Historical Society and the Old Schwamb Mill, and served as chairman of the Arlington Libraries Foundation.

His awards include honorary life membership in the Arlington Historical Society (2000), the Robbins Award (2007), and the Rotary Club's Community Person of the Year (2014).

Richard Duffy has written three photographic histories of Arlington as fundraisers for local organizations and has edited, with commentary, the republication of the 1884 J.T. Trowbridge novel set in Arlington, *The Tinkham Brothers' Tide-Mill*. (Courtesy of Richard A. Duffy.)

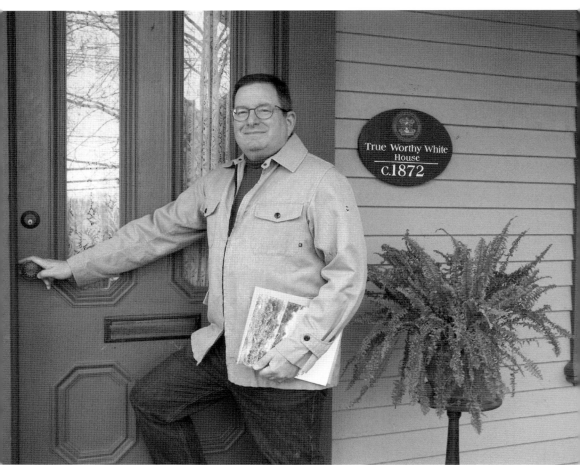

Elsie Fiore

If anyone thinks Elsie Fiore is too old or too tired to fight a project proposed for a wetland, they had better think again. In 2015, when the Mugar Family Trust decided to build housing on a 17-acre plot on a flood plain, Fiore, at age 88, helped organize opposition. During a 45-year period, Fiore helped oppose other efforts to develop the same land. In 1970, when a supermarket was proposed for the parcel, she personally went to court to stop the plan that residents feared would increase traffic, flooding, and sewage backup.

Fiore has been a conservationist and activist since she moved to Arlington in 1949. Concerned about flooding in her neighborhood, she pushed town and local governments to improve the drainage and sewage systems.

She was a founding member of the East Arlington Good Neighbor committee, member and chair of the Arlington Conservation Commission, and member of the Mystic Valley Watershed Association and the Tri-City working group.

In 2006, Elsie Fiore earned the Unsung Heroine Award from the Massachusetts Commission on the Status of Women, and she was named the Rotary Club's Community Person of the Year in 2008.

Fiore was elected to town meeting in 1962. With near perfect attendance for over 50 years, she has been a champion for Arlington's parks, open spaces, and waterways. (Courtesy of the *Arlington Advocate*, March 2006.)

Beverly "Bev" Brinkerhoff

Beverly Brinkerhoff began providing next-day home delivery of books to shut-ins in 1992 and was still going strong more than 20 years later at the age of 88. She calls her elderly or disabled clients, finds out what they want to read, delivers the volumes, and returns books to the library.

Brinkerhoff is much more than a mobile library. She has formed long-lasting friendships with her clients, visiting them when they are sick, running errands, and providing transportation. (Photograph by Barbara C. Goodman.)

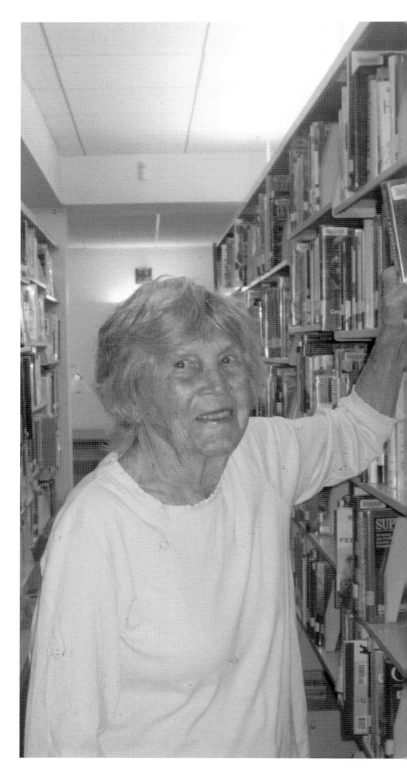

Paul Parravano

When Paul Parravano was three, his father noticed his son did not respond when a ball was thrown to him. After a visit to the doctor, the family learned the boy had a rare form of cancer that left him blind. Nothing has fazed Parravano. After working as a civil rights attorney, he became codirector of the MIT Office of Government and Community Relations. He has served as president of the board of directors of the Housing Corporation of Arlington, formed in 1986 when a group of residents became concerned that rising real estate prices were making it difficult for people to find homes. He once told an interviewer that experiencing the joy, sadness, pain, and excitement of life has less to do with whether one can see than how one relates to others. (Photograph by Marjorie Howard.)

Sally Rogers

After the assassination of Martin Luther King Jr., the Pleasant Street Congregational Church wanted to do something to promote racial justice. Two members, Sally Rogers and Charles Pierce, wanted to establish an integrated preschool by busing students from Boston to Arlington. The church approved their plan and helped with initial funding. Since 1968, the Rogers-Pierce Children's Center has served up to 50 youngsters of all races. For this work, and for her longtime commitment to the Arlington Central America Committee, her support of Arlington's sister city relationship with Teosinte, Nicaragua, and her participation in the 1991 Witness for Peace Program, Rogers received the 2008 MLK award. (Courtesy of the *Arlington Advocate*, January 2011.)

George Capaccio

George Capaccio plays two roles. In one he is an actor and storyteller who has served as an artist and educator in Boston's elementary schools, using stories to support and enrich the curriculum. He has also acted with the American Repertory Theater in Cambridge, worked in theater companies for children, and cohosted a children's television show. In the 1990s, he took on a second part. Concerned about economic sanctions against Iraq, he traveled there nine times, each time writing articles and speaking to groups when he returned to educate them about the effect on civilians, hospitals, and schools. He continues this work closer to home, collecting household goods and clothing for Iraqi refugees in Massachusetts. (Courtesy of George Capaccio.)

Howard Clery

Howard Clery confronted adversity in his life but faced enormous difficulties with a strong resolve not to be defeated. He played varsity football at Arlington High School before being stricken with polio when he was 15. He used a leg brace and walked with a cane for the rest of his life, still managing to play tennis with two hands and becoming a 17-handicap golfer. He earned degrees at Dartmouth College and went to work for Gillette, where he met his wife, Constance. Tragedy struck in 1986 when the youngest of their three children, Jeanne, then 19, was brutally raped and murdered in her dorm room at Lehigh University. The Clerys turned their grief into action, suing Lehigh and using the proceeds to found Security on Campus, whose goal is to inform the public about serious crime on college campuses. The organization was instrumental in the passage of what became known as the Jeanne Clery Act. The law requires colleges to make public any homicides, rapes, assaults, robberies, and burglaries committed on their campuses. In addition to the federal law, the Clerys secured passage of campus public-safety legislation in more than 30 states. (Courtesy of Security on Campus.)

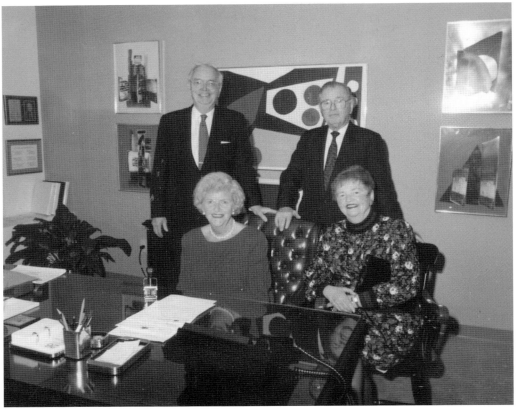

The Casey Family

In 1933, Noreen D. Casey's husband stopped to help someone change a tire, and he was hit by a car and badly injured. Realizing her husband would be unable to work, Casey, the mother of four, started a school at 34 Bartlett Avenue, transforming the two-family residence into a home on one side and a school on the other. The Bartlett School was at that location until 1978, when Casey's daughter, Noreen T. Casey, moved it to Winchester. The younger Casey became principal, retiring in 2000. Both mother and daughter were outgoing and energetic teachers. Since retiring, Noreen D. Casey has traveled around the world. Pictured above are, from left to right, (seated) Eve and Noreen; (standing) Al and John. At right is Noreen D. Casey. (Both, courtesy of Noreen T. Casey.)

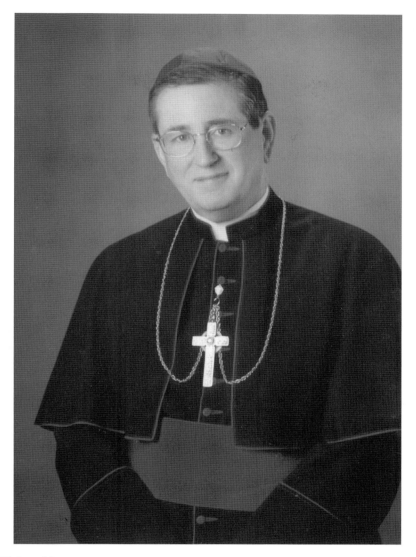

Bishop Richard Lennon

Bishop Richard Lennon grew up in a well known Arlington family, active in the community. In 1914, his uncles helped build what would become Lennon's parish church, St. James the Apostle, where he served as an altar boy. Later, his father, Albert, served as deputy fire chief. Lennon Road is named after his great-grandfather Patrick.

Lennon has followed in the family tradition of helping others. He once hitched a ride on a snowplow so he could celebrate mass for snowbound nuns and during the blizzard of 1978 helped families trapped by coastal floodwaters. In 2002, he was named interim leader of the Roman Catholic Archdiocese of Boston, taking on the difficult challenge of leading the archdiocese right after a scandal. He graduated from Matignon High and Boston College, where he was known as a serious student. He is admired for his administrative skills and his self-taught knowledge of canon law. He is also a Boston College hockey fan and was long faithful to his Arlington barber and the Newton shop where he bought pipe tobacco. In 2006, Lennon was named Roman Catholic Bishop of Cleveland. (Courtesy of the Diocese of Cleveland.)

Pearl Morrison

Morrison is a longtime educator and community activist. Since moving to Arlington in 1972, she has been a member of the Arlington Town Facilities Committee, the civil rights committee, the historical society, and the Democratic Committee. She serves on the executive board of the local NAACP chapter. For the last 30 years, as part of the superintendent advisory committee on diversity, she has worked to increase the number of minority faculty in the schools. She has also helped to introduce a curriculum into the school program that would enhance students' understanding of the African American culture and experience.

Morrison was a founding member of the Martin Luther King Birthday Celebration Committee and has emceed this event for 26 years. As part of this committee and of the Arlington African American society, Morrison has helped raise thousands of dollars for scholarships for students of color who graduate from Arlington High School. (Courtesy of the *Arlington Advocate*, January 2011.)

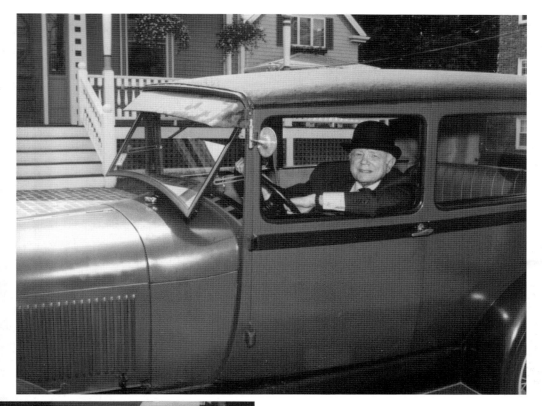

"GOLDEN OPPORTUNITIES" WITH HOST HARRY BARBER

Harry Barber (1922–2001)

Barber was a man of many hats. He sometimes wore a fez or a skimmer, but most often it was a bowler—especially when driving his 1929 Ford Model A.

A decorated World War II veteran, Barber worked as a broker with the Bowes Real Estate Agency for 30 years. Upon his retirement, he created and hosted a television show titled *Golden Opportunities* that focused on issues facing seniors. Barber survived the Armenian Genocide, the Battle of the Bulge, and cancer. He lived life with gusto and a passion for helping others. Barber volunteered to drive cancer patients to their appointments—picking them up in his antique Ford.

Barber was a town meeting member for 20 years. Concerned about the impact of property tax increases on senior citizens, Barber initiated a program by which elders could offset their tax bill by performing community service. At left, Barber is pictured with Mary Lou Bigelow. (Both, courtesy of Beatrice Barber.)

Lenore and Howard Winkler in 1970

As the civil rights movement grew and became more violent in parts of the South, a group of Arlingtonians, headed by Elva Bolton and Charles Johnson, decided to focus on the issues of segregation and inequality in their own town. In 1959, to ensure that people of color were welcome to live in Arlington, they formed the Arlington Fair Housing Committee. The group expanded its mission to include advocacy for employment and educational opportunity and changed its name to the Arlington Civil Rights Committee (ACRC) in 1963. Its membership grew to about 350 over a 35-year period.

Lenore concentrated on housing issues. She worked on Operation Good Neighbor, the town-wide church-sponsored fair housing campaign, to promote Arlington as an inclusive community. Lenore edited a booklet for minority home seekers, *Arlington—A Good Place to Live*, and spearheaded its distribution to Arlington realtors and media outlets within the Greater Boston black community. She served as chair of the League of Women Voters Housing Subcommittee, culminating in a "Study of Low and Moderate Income Housing, 1968–1970." During this early period, ACRC members served as testers in many housing-discrimination cases, including the landmark case that overturned the state statute permitting discrimination in owner-occupied two-family houses.

Howard focused on employment issues. In 1970 and 1999 as a town meeting member, he helped to pass bylaws that promoted equal opportunity for women and minorities in hiring, purchasing goods and services, and construction contracts. Howard also served as president of the ACRC and as a founding member of a low-income mortgage fund for home buyers, Home Owners Equity (HOE).

ACRC also worked on educational issues. In 1966, at the urging of ACRC members, including psychologists Sylvia and Arne Korstvedt and others, the Arlington School Committee voted to have Arlington became one of the first six communities to join the Metropolitan Council for Educational Opportunity, a program that allows inner-city children to attend suburban schools.

The work started by the committee continues today in the efforts of the human rights commission and the Martin Luther King Committee as well as the Housing Corporation of Arlington and the Vision 2020 diversity task force. (Courtesy of Howard Winkler.)

CHAPTER TWO

Arts and Culture

Drive down Massachusetts Avenue in East Arlington and it is hard to miss the home of Shunsuke Yamaguchi. Using his front porch as an open-air gallery, Yamaguchi displays his vivid cartoon-like paintings, catching the eye of drivers and pedestrians alike.

Yamaguchi and his wife, ceramicist Eileen de Rosas, are part of Arlington's lively arts community. Almost any night of the week there is a performance of music, theater, or a reading somewhere in town. Public art has helped transform otherwise ugly utility boxes into creative canvasses. A town-wide block party in the spring draws musicians, craftspeople, and artists thanks to Arlington Alive.

Two key institutions are among the organizations anchoring the arts, the Arlington Center for the Arts and AFD Theater. The arts center was established in 1988 by a group of artists, writers, musicians, and educators. It provides studio space for artists, and its theater offers music and live performances. The center sponsors Shakespeare in the Park, and each year, its open studios draw huge crowds eager for a glimpse of a working artist's milieu. In addition, the ACA, as it is known, offers classes for all ages and a summer camp.

AFD Theater was originally known as Arlington Friends of the Drama. Founded in 1923, it is one of the 10 oldest continually operating community theater groups in the country. The company offers four shows a year, usually a comedy, a drama, and two musicals. It has won regional and national awards and offers opportunities to act, direct, or work backstage. The company aims to develop a next generation of theatergoers and performers by offering a scholarship at Arlington High School and gives students the opportunity to attend final rehearsals free of charge. Young people often participate backstage and even sometimes on stage.

Another enduring part of the town's cultural scene is the Philharmonic Society of Arlington, founded in 1933. The organization consists of an orchestra, a chorale, and a chamber chorus. The three groups present eight concerts a year. Every 25 years, the philharmonic society has celebrated in two ways, by performing Handel's *Messiah* and throwing a party. At its 75th birthday, the tradition continued along with a potluck dinner and performances by small groups of musicians from the orchestra and chorus.

There are other groups: the Arlington Cultural Council provides grant money to applicants whose work is performed or watched or danced to or read. The more recently formed Arlington Cultural Commission advocates for the arts and offers an ongoing calendar of events.

The town even has an art gallery, 13 Forest Street, that is a showcase for contemporary artists. The latest entry into Arlington's busy art world is a plan to appoint a poet laureate, one more example of how the town's arts community continues to grow.

Vittoria C. Dallin (1861–1948)

Vittoria Dallin (née Murray) was a writer and teacher. Her passion for education and the arts led to the establishment of the Arlington Friends of the Drama (currently on Academy Street) and the former Dallin Branch Library in Arlington Heights.

Vittoria held a faculty position at the Boston Normal School (teacher training college) and taught drawing at Girls' High in Boston. Her teaching career ended in 1891 when she married Cyrus Dallin, an aspiring sculptor.

Vittoria was a founding member of the Arlington Heights Women's Study Group, which was established for "self-improvement, social intercourse and to strengthen neighborhood interests." She was also president of the more influential Arlington Women's Club and a board member of the Massachusetts Federation of Women's Clubs.

In 1921, just a few months after the passage of the constitutional amendment granting women the right to vote, Vittoria became the first woman, along with Ida Robbins, to be elected to the Arlington Town Meeting.

Vittoria wrote and directed massive pageants in Boston and Lowell. In 1913, working with other members of the Arlington Women's Club, she organized a celebration for the dedication of Arlington's new town hall. Some 6,000 people came to watch the three-hour pageant that included 600 Arlington performers and other volunteers.

In 1923, Vittoria called a meeting at her home for the purpose of establishing the Arlington Friends of the Drama. Initially, membership was restricted to women. In 1934, when the organization moved to its current location, men were permitted to join. The Arlington Friends of the Drama is one of the oldest community theaters in the United Sates. (Courtesy of the Arlington Historical Society.)

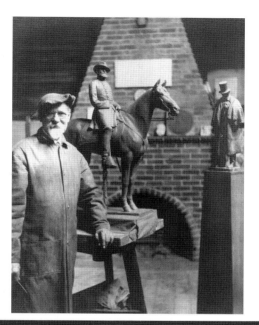

Cyrus E. Dallin (1861–1944)

Though he struggled for recognition for many years, Dallin is now considered to be one of the most important American artists. It took him 58 years to finance and produce his most famous work—the Paul Revere statue that stands in Boston's North End. To support his family, Dallin taught at what is now known as the Massachusetts College of Art and Design. Dallin was born in Utah yet lived and worked in Arlington for over 40 years. His art has been exhibited internationally and can be found in parks and museums across the country.

Dallin's work reflects his reverence for Native Americans and the early Pilgrims. His statue *The Appeal of the Great Spirit* is an exemplar of American art, a small version of which is in the White House. (Right, courtesy of the Robbins Library; below, photograph by Barbara C. Goodman.)

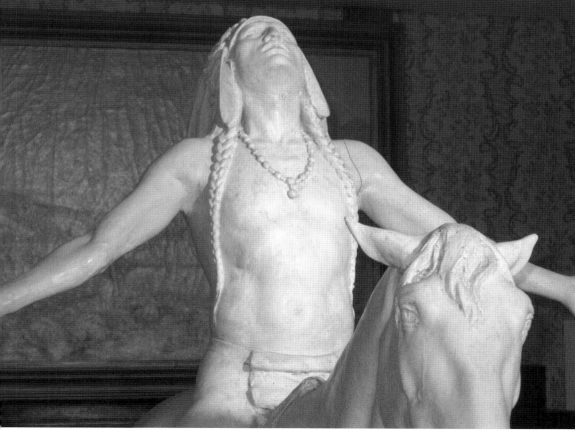

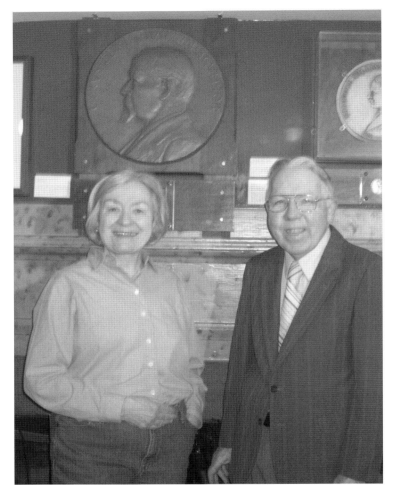

James McGough

James McGough (pictured with Geraldine Tremblay), a painter and man of the arts, moved to Arlington in 1964. A few years later, he located his business, the Town Barber Shop, across the street from town hall, where he had a direct view of the ornate flagstaff that includes four sculptures. McGough was curious; who created this work of art? There was no indication on the flagstaff and no town record. After extensive research, he discovered that sculptor Cyrus Dallin created the flagstaff in 1913.

In 1981, with a $720 grant from the Arlington Arts Cultural Council (AACC), McGough was able to have a plaque placed at the site indicating the artist and the date.

During his search, McGough discovered that the town did not have a registry of any of the art that it owned. He served on an AACC committee that investigated and documented the town holdings. In this process, they found 23 additional sculptures and one painting by Cyrus Dallin. Through private donations, McGough raised $35,000 to restore these works of art.

In 1995, Arlington's town meeting approved McGough's request to create a board of trustees for the purpose of establishing a museum dedicated to Cyrus Dallin. Because McGough had promised that the gallery would not cost the town money, the board sought private donations and grants to purchase, restore, and maintain Dallin's work. The museum opened in 1998 with 23 sculptures. Now, with 93 sculptures and six paintings, it is internationally known and recognized as the main depository of Dallin works in the United States. (Photograph by Barbara C. Goodman.)

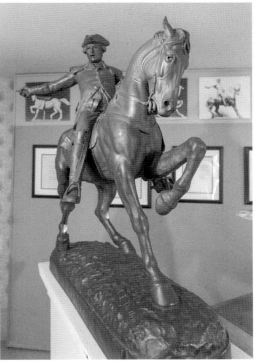

Geraldine Tremblay Teaching at the Museum

Tremblay is mostly known for her years as a teacher of Latin, Greek, and Roman culture at Arlington High School. She has a bachelor of science degree from Boston College and a master's degree from Tufts University. In addition to working at the Boston Museum of Fine Arts, Tremblay's experience cataloguing artifacts on a classical excavation in Stobi, Yugoslavia, gave her the skills needed to research and catalogue Cyrus Dallin's work. In 1996, Tremblay became a trustee of the Dallin Museum, helping fundraising efforts, writing grants, and implementing the museum's educational programs. Because she has given so much of her time and expertise, Tremblay is known as *la doyenne* of the board.

Below is a replica of the Paul Revere statue located in Boston, Massachusetts, sculpted by Cyrus E. Dallin. (Above, courtesy of the Dallin Museum; below, photograph by Joan Roman.)

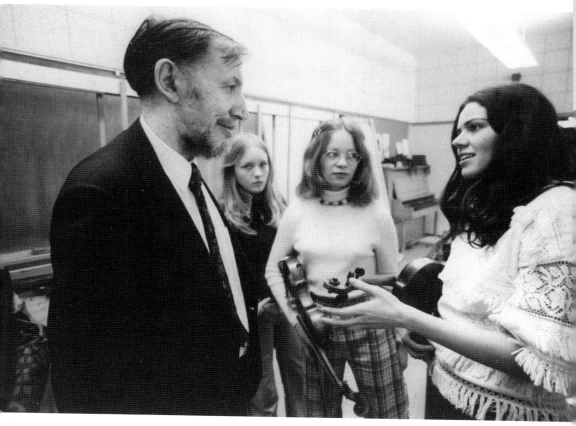

Alan Hovhaness (1911–2000)

Hovhaness, a 1929 graduate of Arlington High School, was a 20th-century American composer of classical, jazz, and avant-garde music. He wrote 500 pieces, including 67 symphonies, nine operas, and, in collaboration with Martha Graham, two ballets. Hovhaness started composing when he was seven years old. His parents believed that was abnormal, so he had to hide in the bathroom in order to write. In 1942, he won a scholarship to Tanglewood. However, he was not appreciated by the established musicians. Despondent, he burned hundreds of his compositions.

Hovhaness was in the forefront of a shift in 20th-century music away from purely Western aesthetics. He incorporated themes from India, Japan, and Korea and other Eastern traditions. His work was not easily accepted, and he struggled artistically and financially.

His first success came in 1944, when he received critical and public praise for his symphony *Lousadzak*. However, it was not until the 1950s that he began to win national and international acclaim. In 1985, his most famous work, *Mysterious Mountain*, was performed and recorded by Fritz Reiner and the Chicago Symphony Orchestra.

Hovhaness received five honorary doctoral degrees. The 1959 award from Bates College in Maine reads, in part, "For boldness and delicacy of imagination, for originality and individuality without eccentricity, for a great number of compositions each fresh and distinctive, for fusing old melody and modern technique and spirit; in short, for making music to lift the hearts of men as only he can." (Courtesy of the Robbins Library.)

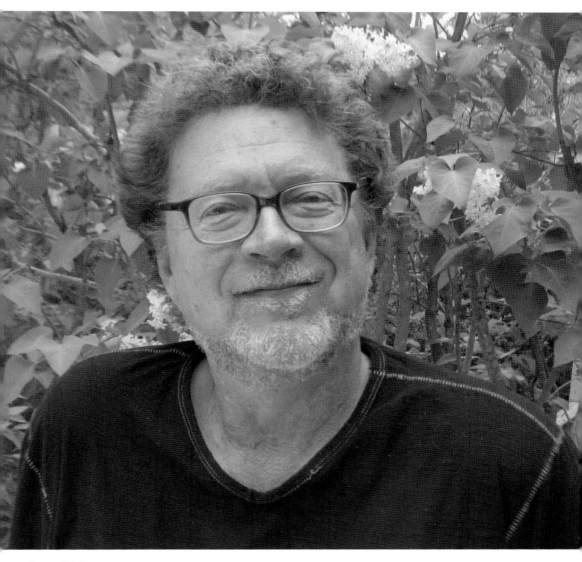

Sven Birkerts

Sven Birkerts is an essayist and critic. His work has appeared in numerous publications, including the *New Yorker* and the *New York Times*. One of his best known books is *The Gutenberg Elegies: The Fate of Reading in the Electronic Age*. Published in 1994, it was reissued in 2006 and was ahead of its time in addressing the future of reading. He has also written a memoir, *My Sky Blue Trades: Growing Up in a Contrary Time*, which talks about his upbringing in a Detroit suburb by immigrant parents from Latvia. He is the editor of *AGNI*, a journal at Boston University, and director of the Bennington College Writing Seminars. He has taught writing at Harvard, Amherst, Emerson, and Mount Holyoke. (Photograph by Marjorie Howard.)

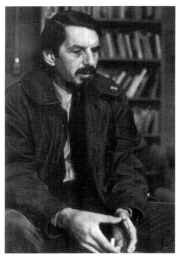

Robert Creeley

Robert Creeley, born in Arlington in 1926, has been described as one of the most important and influential poets of the 20th century. He was also a novelist and short-story writer. He was associated with the Black Mountain Poets, based at Black Mountain College in North Carolina. The program launched artists, writers, and musicians who spearheaded the avant-garde in the 1960s. Creeley's own poetry was known for its concision and emotional power. He wrote or contributed to more than 60 books. (Courtesy of the University of Buffalo.)

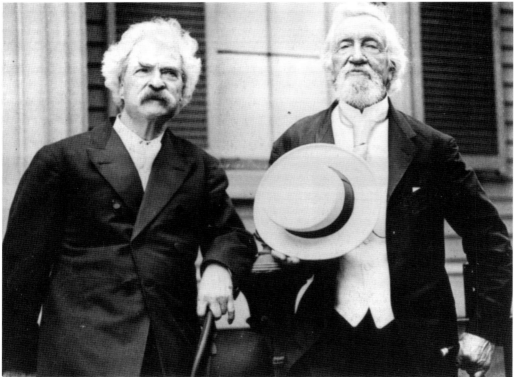

John Townsend Trowbridge (1827–1916)

The 40 novels Trowbridge wrote for boys were both entertaining and instructive and were often based on his experiences living in Arlington. His work, which includes adventure and travel stories as well as poetry, was also enjoyed by adults. He wrote stories for magazines and newspapers in monthly serials that became novels. Along with Henry Wadsworth Longfellow, he was a founding contributor to the *Atlantic Monthly*. Trowbridge (right) is pictured here with Mark Twain. (Courtesy of the Arlington Historical Society.)

Jessie Brown

Jessie Brown is a poet and teacher who leads workshops in schools, libraries, and community centers. Along with Gail Roby, Anna Michaud, and Susan Lloyd McGarry, she founded the Alewife Poets, all published poets who perform together and separately. Brown is the author of two poetry collections, and her work has appeared in local and national journals. She has collaborated with Arlington artist Adria Arch on outdoor installations combining art with poetry. (Courtesy of Jessie Brown.)

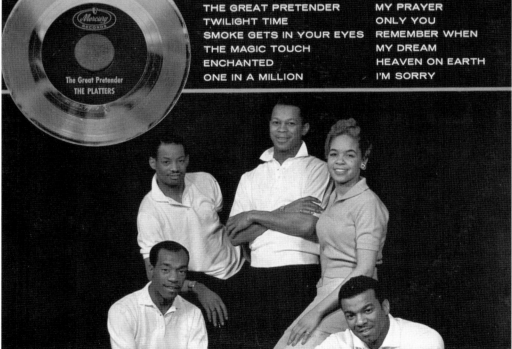

Herb Reed

Born into poverty in Missouri in 1928, Herb Reed (bottom left) began singing in gospel choirs and soon was winning amateur singing contests. He moved to Los Angeles and joined a group of friends who sang together. Reed dubbed the group the Platters after vinyl records and the quintet began recording hits, including *Smoke Gets in Your Eyes* and *Only You*. Reed moved to Arlington in the 1970s, and when he died in 2012, the Regent Theater held a musical tribute attended by 250 people. Soloists, choirs and doo-wop singers all paid tribute to Herb Reed. (Authors' collection.)

Eric Stange

Eric Stange, executive producer and founder of Spy Pond Productions, is an award-winning independent documentary film producer, director, and writer. His work focuses on social and political history as well as science.

Pictured here with Bode Estus (left), he has made dozens of short and feature-length films. *The War That Made America* (2006), *Brother, Can You Spare a Billion?: The Story of Jesse H. Jones* (2000), *Murder at Harvard*, and *James Baker: The Man Who Made Washington Work* (2015) are a few of his best-known works.

Stange is at the forefront in using new technology to make history come alive. He creates iPhone-based walking tours—including one of Beacon Hill, Boston, based on a real-life 1849 murder.

His work has been broadcast on PBS, the Discovery Channel, and the BBC, He has been a research fellow at the Charles Warren Center for Studies in American History at Harvard University and a visiting fellow with the Woodrow Wilson National Fellowship Foundation.

Stange has written about art and culture for the *New York Times*, the *Boston Globe*, the *Atlantic Monthly*, and *American Heritage* magazine. He has been on the board of *Common-Place*, a website devoted to early American history.

Besides traveling all over the world and interviewing presidents and other heads of state, Stange remains involved in his community. He is on the boards of both the Arlington Center for the Arts and the historical commission. He has helped Arlington Community Media to engage youth in moviemaking and has been a judge for local film festivals. (Photograph by Liane Brandon.)

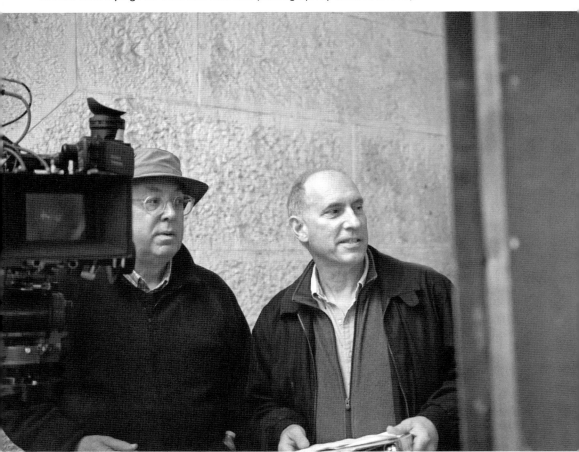

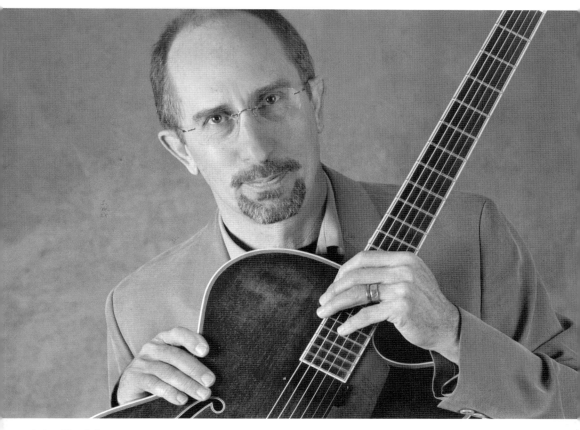

John Kusiak

One has probably heard his music without knowing it: John Kusiak composes music for PBS, commercials, live performances, and movies. He has written the music for some 15 productions of *American Experience* and for H&R Block and Quaker Oats, among other companies, writing from his home studio. He began as a rock-and-roll guitar player, traveling with bands across the country, but settled down to have a family and find work, first in a sound studio and then as a composer. He often works with filmmaker Errol Morris, writing some of the music for *The Fog of War*, which won an academy award in 2004. Kusiak has worked with Arlington filmmaker Eric Stange and won prizes in his own right for the score for *Tabloid*, another Morris film, and *Where Past is Present*, produced for the National Park Service's Salem Maritime National Historic Site. Much of his work is in collaboration with a film's directors and editors. "The director will say 'at this point we're looking for a certain mood to go along with it,' so part of it is my artistic choice, but it's also in cooperation with the filmmaker."

Commercials present a different challenge because of their brevity. Kusiak once said that he thinks of commercials as the kind of work a painter does who makes a tiny painting as opposed to working on a big canvas. Commercials, he says, are only about 30 seconds long, giving a composer very little time to convey an impression, so the challenge—and the fun—is there. (Photograph by Susan Wilson.)

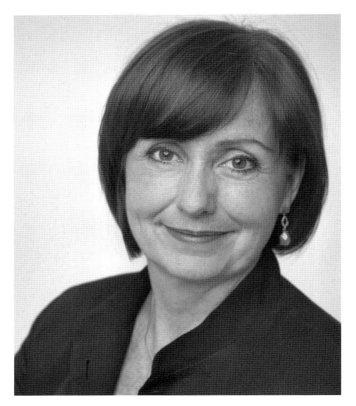

Jennifer Preston (ABOVE)
Jennifer Preston graduated from Arlington High School in 1976 and studied journalism at Boston University. She worked for *Newsday* for a decade, covering police news and politics. In 1995, she went to the *New York Times*, where her jobs have included New Jersey State House bureau chief and newsroom executive. In 2009, she was named the newspaper's first social-media editor. In 2013, *Fast Company* magazine named her one of the 25 Smartest Women to Follow on *Twitter*. She is the author of *Queen Bess*, a biography of Bess Myerson, and in 2014 became vice president for journalism at the Knight Foundation, which promotes journalism and advances media innovation. (Courtesy of the Knight Foundation.)

Susan Hilferty (RIGHT)
Susan Hilferty grew up in a large family that had no television, so reading—and later sewing—was how she entertained herself. By the time she was 12, she was making her own clothes. Today, Hilferty is a renowned costume designer best known for her costumes for *Wicked*, which earned her a 2004 Tony Award. She has designed costumes for more than 300 plays, operas, films, and dance productions. She was nominated for a Tony for *Spring Awakening* and *Lestat* and earned Tony and Drama Desk nominations for *Assassins* and *Into the Woods*. She is also the chair of the department of design for stage and film at New York University's Tisch School of the Arts where she tells students to learn to be curious about the world, just as she was as a child who loved to read. (Courtesy of Susan Hilferty.)

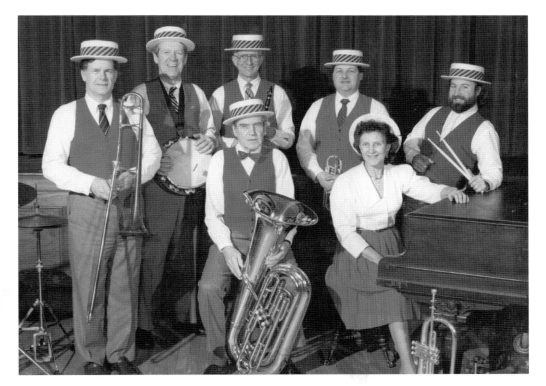

Eva Balazs

Eva K. Balazs and her husband bought a home on Spy Pond in 1952. There, Balazs raised two children, organizing neighborhood events and traveling through town on her bicycle. She earned a doctorate and became a family therapist at McLean Hospital. She was a mainstay of her neighborhood, providing swimming lessons so local children could learn how to be safe in the water and teaching gymnastics at the Parmenter School and physical fitness classes at what was then the Boys Club. She swam, boated, and skied on Spy Pond and encouraged her own children as well as their friends to enjoy pond life too.

She kept a diary during the 1950s and 1960s and used it as the basis of her book *Spy Pond Stories*, which chronicles life around the pond during each season. She describes a time when families were active, skating on the pond in the winter and rowing or canoeing in good weather. Families had parties along the shoreline, and she recalls skating at night under the stars and then enjoying hot cocoa and doughnuts at the home of a neighbor. After a snowfall, she would cross-country ski across the pond. Balazs taught her children to forage for mushrooms or crab apples. The family produced maple syrup from trees in the backyard.

In 1966, word came that Route 2 would be widened, and the following year, Balazs and her neighbors watched with sorrow as trees were cut down and acres of the pond were filled in. In 1978, they had success protecting their pond, managing to get a ban on motorized boats, which are unsafe and harmful to the pond's ecology.

Among Balazs's accomplishments was a regular column in the *Arlington Advocate* and, at the age of 60, the revival of her piano playing, as she began performing with the New New Orleans Jazz Band.

Balazs's two children have had distinguished careers of their own. Marianne E. Balazs is the world's authority on early American painter Sheldon Peck and made a major contribution to art scholarship. Her brother, Andre T. Balazs, owns properties around the world, including the Standard High Line in Manhattan, where his mother still plays piano in the lounge. Their father, Dr. Endre A. Balazs, was a medical scientist whose research has vastly improved eye surgery and the treatment of osteoarthritis. (Courtesy of Marianne E. Balazs.)

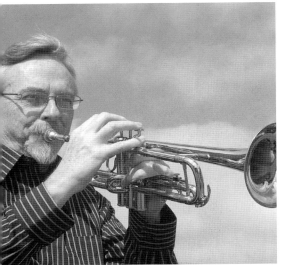

Mark Harvey

Mark Harvey blends his passion for music with his life as a minister and educator. As founder and principal composer of the Aardvark Jazz Orchestra, which began in 1973, he is a stalwart of Boston's jazz community. A trumpet player, he also founded the Jazz Coalition, Inc., which produced concerts and educational activities throughout Boston. He holds a doctorate in religion and is an ordained minister and founder of the jazz arts ministry in Cambridge that performs outreach to the musical community. He teaches at MIT, has performed in numerous concerts, and released 12 albums. He has composed more than 200 works for jazz, choral, brass, and wind ensembles, including music for work by his wife, filmmaker Kate Matson. Among his awards is the designation Grand Bostonian. (Photograph by Kate Matson.)

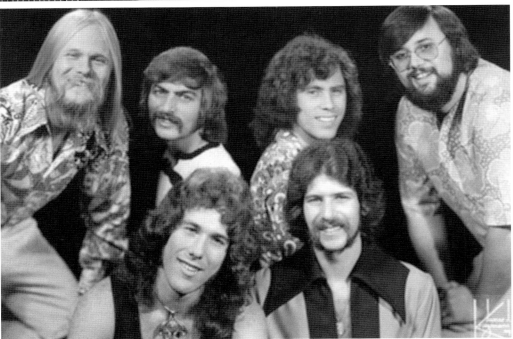

Chico Ryan (1948–1998)

David-Allen Ryan, bottom left, was born in Arlington in 1948 and graduated from Arlington High School. He is better known to his fans as Chico Ryan, a member of two rock 'n' roll groups: Sha Na Na and the Happenings. Ryan first joined the Happenings, a New Jersey band that performed 1960s songs and had a hit with "See You in September" in 1966. In 1973, Ryan joined Sha Na Na, a novelty group that sang songs from the 1950s. Ryan played bass and sang vocals. Along with the other members of the band he dressed the part of a greaser, wearing a motorcycle jacket and slicked-back hair. From 1977 to 1981, he and the group were in a hit television show named for the band and performed in the movie *Grease*. (Courtesy of Bob Miranda.)

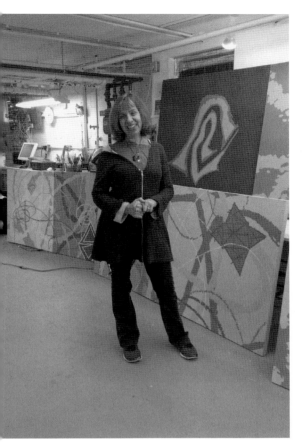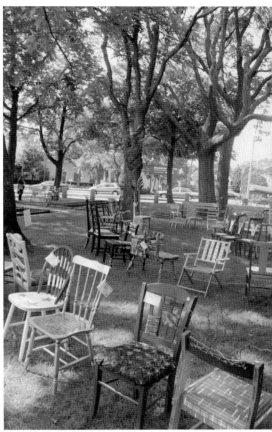

Adria Arch

Adria Arch's artwork has been exhibited in galleries throughout the region, and her work is in national collections of corporations and libraries. Among her accomplishments is serving as chair of a dozen people who make up Arlington Public Art, which seeks to enrich public spaces with original art that adds to the town's historical, cultural, and natural resources. The group works in collaboration with the Arlington Center for the Arts and Vision 2020. Its first project was a mural for the Arlington Boys and Girls Club, overlooking Spy Pond. When funding fell short, Arch proposed an installation called Chairful Where You Sit, which is now a yearly event. Residents transform old chairs into whatever their imagination suggests, and sales of the chairs have raised enough money for the mural as well as other projects, including *Menotomy Rocks*, a temporary outdoor art exhibition. (Both, courtesy of Adria Arch.)

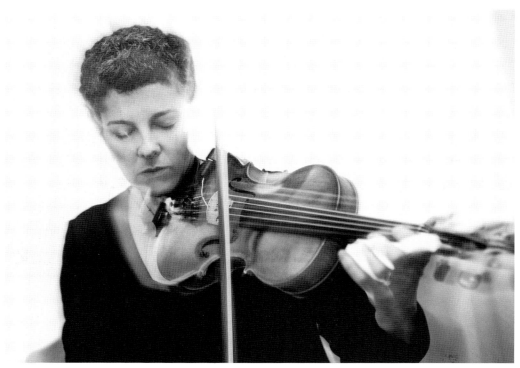

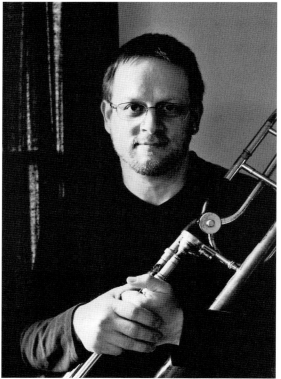

Mimi Rabson and David Harris
Mimi Rabson is a composer and violinist with a diverse résumé. She appears regularly in classical, jazz, klezmer, and other eclectic performances. She is a first-prize winner of the Massachusetts Cultural Council Fellowship in composition and a founding member of the Klezmer Conservatory Band. She appeared with Itzhak Perlman on the recording "In the Fiddler's House" and on *The Late Show with David Letterman.* Her husband, David Harris, has distinguished himself on trombone and tuba and as a composer and arranger in a multitude of musical styles. He has performed around the world at jazz festivals, Lincoln Center, and Carnegie Hall. He is composer and arranger for the Jazz Composers' Alliance, has been featured in soundtracks for television, commercials, and movies, and has played on more than 50 albums. Harris has won the Massachusetts Cultural Council Fellowship for music composition three times. (Above, photograph by Brit Woollard; left, photograph by Liz Schnore.)

Barry Singer

One might call Barry Singer the Music Man. He is a conductor, composer, and singer and plays at least five instruments. He conducts both the Arlington-Belmont Chorale and its chamber chorus, both affiliated with the Philharmonic Society of Arlington, which also includes the orchestra. The society premiered three of his chorale works, and he composed the music for the off-Broadway play *Looking for Billy Haines*. He has sung with the Tanglewood Festival Chorus and plays a variety of instruments with such groups as Firefly and the Boston Windjammers. In his busy music career, he finds time to teach and be an accompanist. (Courtesy of Barry Singer.)

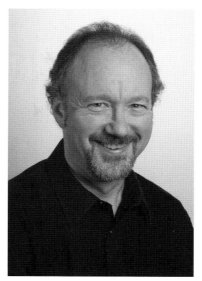

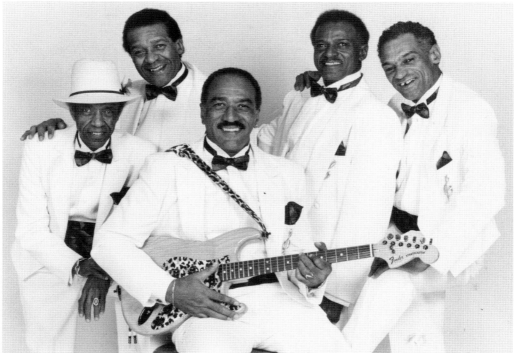

Teddy Scott

Teddy Scott was a member of the G-Clefs, a doo-wop group from Roxbury made up of four brothers and a childhood friend. They began singing in 1952 and had two big hits, "I Understand Just How You Feel" and "Ka Ding Dong," which was the first Boston-area rock 'n' roll record to make the national charts. They performed at Revere's Rollaway and later sang at the famed Apollo Theater in Harlem as well as in Las Vegas, Japan, and across Europe. The band members are, from left to right, Ray Gipson and Teddy, Tim, Chris, and Ilanga Scott. (Courtesy of Teddy Scott.)

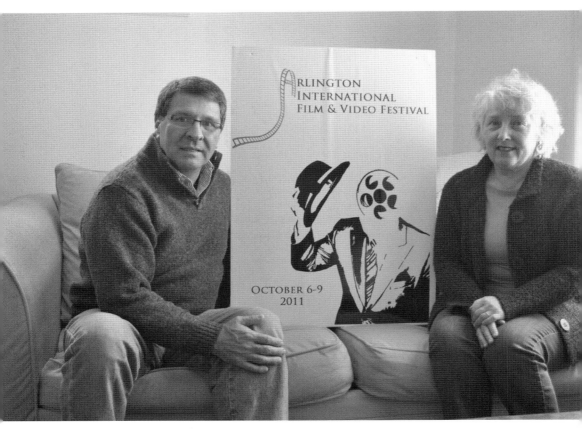

J. Alberto Guzman and April Ranck

J. Alberto Guzman and April Ranck are cofounders of the Arlington International Film Festival, begun in 2011. Guzman fell in love with movies in his native Colombia, and Ranck remembers intense conversations about Ingmar Bergman movies in college. The couple, both former teachers, established the festival to promote cultural understanding and demonstrate Arlington's diversity. It has earned recognition from the Massachusetts Cultural Council and the *Boston Globe*. The festival is held in October, but its influence is felt year-round with a poster contest involving high school students and films shown at the Robbins Library throughout the year. The films, from such countries as Brazil, Canada, South Africa, and beyond, offer a glimpse into other lives and cultures. (Photograph by Marjorie Howard.)

Alan Wilson

Alan Wilson, bottom right, graduated from Arlington High School in 1961, performing music locally with friends from school. He studied music at Boston University and was especially fond of the blues, writing articles on the subject for music publications. He cofounded Canned Heat, playing guitar and singing vocals. The group performed at the Monterey Pop Festival in 1967 and at Woodstock in 1969. Its biggest hit was "Going Up the Country," featuring Wilson's distinctive tenor. (Authors' collection.)

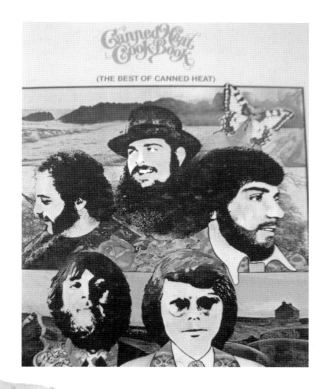

Vance Gilbert

Known for his exuberant onstage persona, Vance Gilbert is from Philadelphia but has long called Arlington home. He is a versatile performer, playing a deft guitar and mixing standards and jazz with his own songs, which tell poignant and often funny stories. He can be seen walking his dogs near Stratton School and is as friendly and funny off-stage as when performing. He plays locally at Club Passim in Harvard Square and tours around the country. (Photograph by Chris Parent.)

59

PHOTO: J.Brian Buckley

Deborah Henson-Conant

While shopping at the town's farmers' market, Arlington residents have had the pleasure of being serenaded by Grammy-nominated electric harpist Deborah Henson-Conant. Her artistry is hard to define. She is an award-winning singer, composer, comedian, and storyteller. She plays jazz, folk, flamenco, and Celtic music. Henson-Conant is known for her high-energy performance regardless of whether she is performing with a major orchestra or in small jazz clubs. She is also curator of the Burnt Food Museum. (Courtesy of Deborah Henson-Conant.)

Anne and Christopher Ellinger

The couple founded True Story Theater in 2001, offering improvisational performances and workshops for community organizations as well as to individuals in order to promote social healing. Volunteers from the audience share what is important in their lives, and actors portray the heart of what they heard, using music, movement, and dialogue. The couple also founded Bolder Giving, a national initiative that encourages a culture of giving based on stories of people across the economic spectrum. (Courtesy of the True Story Theater.)

Leland Stein

Arlington's venue for live entertainment is the Regent Theater, where family-friendly shows on Saturday mornings are replaced by an eclectic mix of theater, comedy, and music in the evenings. Leland Stein is co-owner and manager of the 500-seat theater, a local landmark established in 1916. Stein's own wide-ranging background makes it work. At Clark University, he arranged bookings for campus events, was arts and entertainment editor for the school newspaper, and hosted a radio show. Later, he worked for a record store and Rounder Records. He joined the Regent in 2002 and co-owns the theater with Richard Stavros. One of the theater's most popular events is a *Sound of Music* sing-a-long, but there are also rock 'n' roll, blues, and famed performers such as Art Garfunkel and Paula Poundstone. (Left, photograph by Joey Walker; below, photograph by Matt Oberman.)

Suzanne McLeod

When Boy Scouts built a kiosk on conservation land near her home, Suzanne McLeod sensed an opportunity. Nothing was posted on the kiosk, so McLeod, an artist and therapist, transformed the blank space into a poetry board. She created a blackboard, providing information about the Mount Gilboa conservation land and the format of haiku. Neighbors, visitors, and those out for a walk took over, writing haikus or messages to each other. McLeod has participated in other public and interactive arts projects. A project at the First Parish Unitarian Church encouraged women to express their feelings about taking care of their mothers while also taking care of children; still another project at Mount Gilboa called Land Mine, Land Ours, invited visitors to place red stones in the area. The idea came to McLeod when she learned that in Afghanistan, red stones mark the location of land mines, and she wanted to pose questions about the impact of war. (Photograph by Marjorie Howard.)

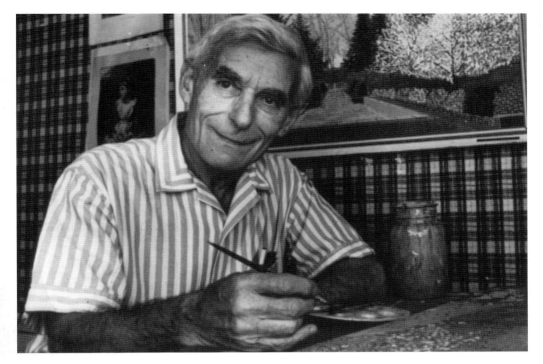

Gideon Cohen

Gideon Cohen was Arlington's Grandma Moses, learning how to paint at age 70 after a career as a furrier. He taught himself by watching educational television, and many of his paintings were of his flourishing garden. Born in England in 1894, his parents were pacifists and sent him to Canada to work on a farm to avoid going into the army. He wanted to become a farmer but instead became a furrier. He moved to Arlington in 1923 and married Lillian Leight. He died in 1989. Each year, the Arlington Cultural Council presents the Gideon Cohen Award to an outstanding fine-arts student at the high school. (Courtesy of the Arlington Historical Society.)

Chris Smither

Chris Smither is a folk singer and songwriter whose work is rooted in the blues. He is known for his acoustic guitar playing. He has often performed with Bonnie Raitt, whose performance of his "Love You Like a Man" is one of her signature songs. He has long been a part of the Boston-area folk scene, performing at venues such as Arlington's Regent Theater and Passim's in Harvard Square. (Photograph by Jeff Fasano Photography.)

Pasquale Tassone

Pasquale Tassone, teacher and composer, grew up in Arlington. While in high school, he played the drums, developed a love for music, and harnessed a desire to help others connect to the world of music. He attended the University of Massachusetts at Lowell, earned a degree in music education, and returned to Arlington in 1972 as a middle school music teacher. Except for time off taken to earn a doctoral degree in music composition from Brandeis, Tassone has spent his entire career doing what he loves—inspiring young musicians.

He became head of the performing and fine-arts department at Arlington High School in 1999, overseeing 24 staff members who implemented a kindergarten-to-12th-grade music and art curriculum. During his tenure as director, school ensembles auditioned for and were invited to perform at the Massachusetts Music Educators Association convention in both the All Eastern Conference as well as the National Conference.

In 2000, he wrote *Pieces of Dreams* for the high school's Honors String Orchestra and Madrigal Singers, which was performed at the town's Martin Luther King Annual Celebration. He has also written music for the Arlington Philharmonic Orchestra and the Belmont Chorale.

Tassone has reached out to the community. His Arlington student musicians performed at the Arlington Senior Center, town meeting, and numerous other special events. In 2006, he established the Menotomy Concert Series. Four times a year, Arlington amateur and professional musicians give free concerts for the public. Tassone has served on the cultural council, the committee for the Alan Hovhaness Memorial, and the committee for the town meeting's centenary celebration. In 2007, Tassone was awarded one of the 200th Anniversary Awards by the Town of Arlington.

He has composed for a variety of ensembles, both choral and instrumental, large works as well as chamber music, and most recently an opera titled *Seven Rabbits on a Pole*. His works have been performed around the world and won numerous prizes, including the University of Massachusetts Lowell Distinguished Alumni Award (2001), and the Pirandello Lyceum "I Migliori" award (2009).

He won first prize in Catholic University's composition contest (1999) with his *Laudate Dominum*, which premiered at the Kennedy Center in Washington, DC. Pasquale Tassone was a founding member of the Lumen Contemporary Music Ensemble, dedicated to presenting contemporary music concerts in the Boston area. (Courtesy of Pasquale Tassone.)

CHAPTER THREE

Public Spaces

Arlington's forebears had the generosity and foresight to endow the town with a gift that almost 200 years later is continually enjoyed.

In 1807, just a few months after the town was incorporated, the West Cambridge Social Library was established. It was a private club with dues-paying members.

In 1835, Dr. Ebenezer Learned, a physician from Hopkinton, New Hampshire, left $100 in his will to establish a free juvenile library in Arlington, which was then called West Cambridge. The bequest was for "grateful remembrance of hospitability and friendship" for the time he lived and taught in the town.

Legend has it that Jonathan Dexter, the town's first librarian, carried the new children's books to town in a wheelbarrow. For about one year, the newly formed West Cambridge Juvenile Library was located in his home at the southeast corner of Pleasant Street and Massachusetts Avenue. A plaque can be found at this site.

Dr. Learned generously allowed the town to establish the Arlington Juvenile Library—the first continuously operated children's library in the nation. Two years later, the town authorized an annual appropriation of $30 so that the library would be free to the adults as well as children. In 1870, the library was renamed the Arlington Public Library.

In the mid-1980s, Arlington had three libraries within a 3.5-mile stretch of road.

In the center of town, Marie C. Robbins moved the family home to make room for a library that was built and furnished in 1892 in memory of her husband, Eli. A century later, Margret Spengler led a successful capital campaign to renovate and expand this library. The East Arlington Branch Library was formed in 1917 in the basement of the Crosby School. It then moved to two storefronts at the corner of Cleveland and Massachusetts Avenues, the current location of the Edith Fox Library.

In the west, the Vittoria C. Dallin Library was built in 1938 on Park Avenue near Massachusetts Avenue. It closed in 1989 due to fiscal constraints. The building is now the home of Arlington Community Media, Inc.

Fearing that the Fox Library would also be permanently closed, Hilary Rappaport formed a nonprofit corporation. She and her original board members developed a vision and a plan that has not only kept the library open but has enhanced it.

Arlington owes a great debt for these enduring legacies.

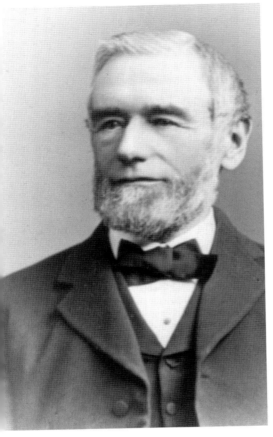

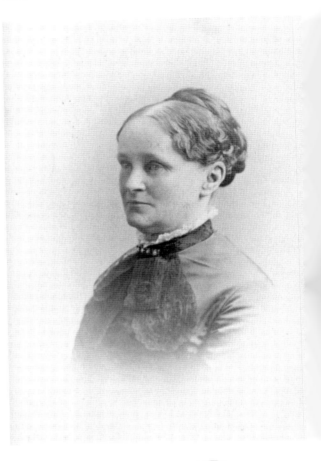

The Robbins Family

Nathan Robbins and his younger brothers Amos and Eli made their fortunes as purveyors of poultry. In 1847, Nathan Robbins (below) and his wife, Rebecca, bought the mansion now known as the Whittemore Robbins House. In 1880, their four orphaned grandchildren, Ida, Olney, Eliza, and Caira, came to live with them. Olney died in 1905. In his name, the Robbins sisters gave the town a water trough that still stands where Lowell Street and Massachusetts Avenue meet. In 1892, after the death of Eli (above left), his widow, Maria (above right), gave money to the town to build the Robbins Library. It cost $150,000 and was noteworthy at the time for its architectural features. The Robbins Memorial Library is in the National Registry of Historic Places. (All, courtesy of the Arlington Historical Society.)

Winfield Robbins

Winfield Robbins, the eldest son of Amos Robbins, donated many prints and other art objects to the library. He died in 1910, leaving money to build the Amos Robbins Memorial Town Hall. In turn, the Robbins sisters gave money in his name for the Winfield Robbins Memorial Garden, including the Dallin statue of the Menotomy Indian hunter. Below is the library reading room with art donated by Winfield Robbins. In 1932, Ida and Caira, the two still-living sisters, gave the Whittemore Robbins House to the town. They asked that it be used for welfare work, and it is the current site of the Arlington Youth Counseling Center. (Left, courtesy of the Arlington Historical Society; below, photograph by Barbara C. Goodman.)

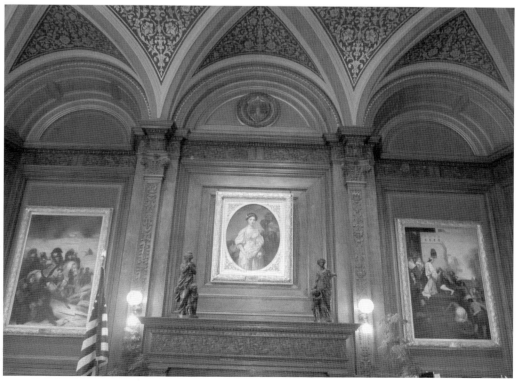

Caira, Eliza, and Ida Robbins

Ida Robbins was the most civically active of the three sisters. She was a member of Museum of Fine Arts, the Society for the Prevention of Cruelty to Animals, and the Arlington Historical Society. During World War I, she was chair of the Arlington branch of the American Red Cross. In 1905, the first year that women could vote in town elections, Ida was elected to the school committee. She, along with Vittoria Dallin, saw to it that paintings and sculptures were placed in schools and other public buildings. When Ida died in 1949, she left many bequests to Arlington institutions and citizens, including a fund that continues to provide scholarships to Arlington's best and brightest high school graduates. Eliza is at left above, Ida is at right above, and Caira is at left. (All, courtesy of the Arlington Historical Society.)

Edith M. Fox (1871–1965)
Edith Fox inherited her fortune from her father, who owned the Fox Baking Company. When she died at age 94, she left $4.54 million to 27 charities, including money to expand the library. In 1969, the East Arlington Branch Library was built and dedicated in her name. This was not her first contribution to the town's library. In 1931, she is believed to have given an anonymous donation of $5,000 to establish a fund, the income from which would go to purchase children's books. The fund has grown and now has $84,000. Fox was also known for her love of children. She helped establish the Arlington Boys Club and the first playground in town. She also donated money to schools in the South that educated children of color. (Both, courtesy of the Arlington Historical Society.)

Hilary Rappaport

In 2003, facing a financial crisis, the town slated the Fox Library for closure. Rappaport helped form the Friends of the Fox, which fought successfully to keep the branch open, promising to raise private funds to supplement town funding. The group raised $50,000, and the library stayed open three days a week for two years. In 2005, the town agreed to take over the funding. To Rappaport, whose family has had a deep appreciation for libraries, this was insufficient. In 2008, she formed a nonprofit corporation, Friends of the Fox Library, and with fellow board members and volunteers implemented a plan that included opening a volunteer-run children's resale shop, women's clothing sales, and fundraising events. The Friends enable the Fox to be open four days a week. They support resources, renovations, and programming and advocate for increased hours and activities. (Courtesy of Shunsuke Yamaguchi.)

CHAPTER FOUR

Public Service

With one exception, the people in this chapter are public servants who went well beyond their job descriptions to serve their community and their country. They are people who are more than hardworking, reliable, and honest. In war and in peace, in good times and bad, they have dedicated themselves to the common good.

In this chapter, the brave soldiers and police officers who have stood in harm's way are profiled. Arlingtonians took on dangerous missions as navigators and bombardiers for the Doolittle Raiders, who were the first to bomb Tokyo during World War II.

In this chapter are stories of a junior high school principal who visited the homes of troubled students; a social worker who created programs to meet the needs of the most vulnerable in the community; a school superintendent who stood up against a corporation that polluted the land next to the high school; and a town planner who fought for 14 years so that the old railroad right of way could become the 10-mile-long Minuteman Commuter Bikeway. This section includes town officials who took political risks to advocate for raising taxes to pay for the rebuilding of schools and to support programs for seniors and youth. With little or no pay, they have given their time and energy to make the town a thriving community. Also featured here are two political families who, through several generations, have dedicated themselves to their town and their country.

This chapter includes two trailblazing women who sat on the board of selectmen. One was the first to be appointed to this committee, the other the first to be elected.

This chapter describes men and women who, despite their different backgrounds and political views, came together to serve and protect, build new schools and expand the library, care for the elderly and support the youth, and provide for the needy.

The Hurd Family Nine

The Hurd family has had a continuous presence in Arlington since 1892, when Alberta Hope (née Hurd) and her husband moved to Arlington from Toronto, Ontario. A few years later, Alberta's widowed mother arrived with Herbert, her 14-year-old son. Herbert Hurd (1871–1946), his sons, and his grandsons have had a lasting impact on Arlington.

Herbert and his wife, Catherine, had 10 children—eight boys and two girls. The children and their friends played on a field at the Wiggins/Bowles estates. Herbert petitioned the town to purchase the field and make it a public park. The town took it by eminent domain and named it Reservoir Field.

This field became the place of a unique sporting event. Herbert and his eight sons formed their own semiprofessional baseball team called the Hurd Family 9. They played for fun, to raise money for different charities, and from 1935 to 1941 they competed in the Suburban Twi-Light League. Their games become a major pastime for town residents. All of Hurd's children and grandchildren were involved in sports, the girls as cheerleaders and the boys as team members or coaches or often both.

Five of the eight Hurd boys fought simultaneously in World War II. Walter, the youngest, was killed in battle. In 1968, Reservoir Field was renamed the Walter G. Hurd Field in his memory. This park is now used regularly by Arlington soccer and softball teams. (Courtesy of Frank Hurd Jr.)

Franklin W. Hurd Jr. and Sr.

Franklin Hurd Sr. was the first member of the family to serve the town in an official capacity. He was a member of the board of park commissioners and the board of public works. In 1953, he was elected to the board of selectmen and served for two terms. He also was a member of numerous county and state boards. Frank Hurd originated Student Government Day, which remains an annual event at Arlington High School.

Frank Hurd Jr. followed in his father's footsteps. After serving four years as a town meeting member, he was elected to the board of selectmen and served from 1988 to 1994. In 1994, Frank became the executive director of the Arlington Housing Authority, retiring from that position in 2007. He was one of the original members of the affordable housing task force and the Housing Corporation of Arlington. (Courtesy of Frank Hurd Jr.)

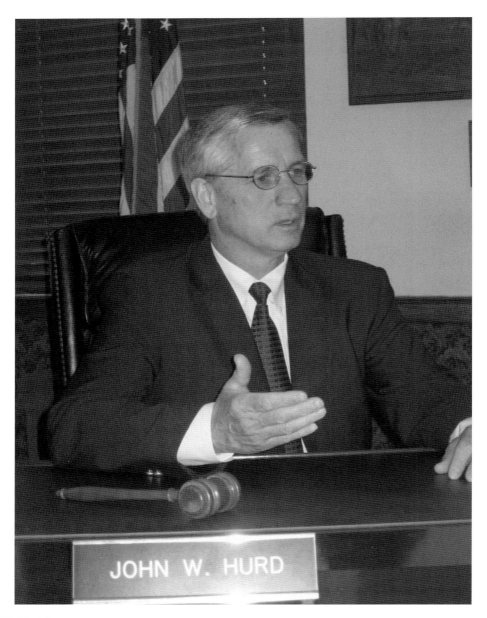

JOHN W. HURD

Jack Hurd

Jack was seven years old when his father died. Having accompanied his father to work at the skating rink, he developed a love for hockey. He started to play in elementary school and was a star of the Arlington High School team. He coached teams at Arlington Catholic High School and won division and state championships.

Jack Hurd's public service includes five years as a town meeting member and 15 as a selectman. He is credited for helping to keep the Fox Branch Library open during a financial crisis. He initiated several town celebrations, including the Feast of the East and the Fourth of July event at Robbins Farm Park. He is a member of the Friends of Fox Library and on the board of the Children's Room, a program that helps grieving children. (Courtesy of Frank Hurd Jr.)

Joseph P. Greeley (1908–1989)

Greeley taught his children the importance of contributing to their town and country. He set the example by serving for a total of 24 years (1950–1974), first on the Arlington Board of Public Works and then as a selectman.

Greeley was a proud World War II Navy veteran. When he saw that returning soldiers were marrying and having difficulty finding housing, he urged the town to develop more multifamily homes. He was a man of strong opinions and a mesmerizing orator. Greeley was known for working well even with those with whom he disagreed. He was so popular that John F. Kennedy personally asked for his support when he ran for senate and for president. Greeley Circle is named after him.

In 1946, Joseph married Elizabeth Flanagan. She too was involved in community life and was president of the Catholic Women's Association. They raised six children.

Mary Anne Greeley (1948–1992) was a dedicated second grade teacher at the Stratton School. When she died at age 44, the playground at the school was named for her. Each year, the family holds a golf tournament to raise money for the Mary Anne Greeley Scholarship Trust. Over the last 20 years, over $80,000 has been given out to needy students. (Courtesy of the Arlington Board of Selectmen.)

The Greeley Family

Robert, known as Bobby, was a medic in the Air Force Reserve. He was a town meeting delegate and elected to the board of assessors in 1985 for his background in accounting and economics. He resigned in 1987 to become the director of assessments. He retired in 2011. Bobby loved his job and took pride in making the assessor's office accessible and transparent to the public.

Kevin won his first election to the board of selectmen in 1989, just two weeks after his father died. He was voted in eight more times, including eight years as chairperson. Kevin, though initially the shiest of the Greeley children, was inspired by his father's ability to captivate an audience. He attended Emerson College, earned a position on the debate team, and competed in the United States and Europe. After earning a master's degree in business communications, he worked for a private corporation and then in 1999 formed his own company. Greeley Communications provides training in public speaking and sales for corporate executives. Kevin helped lead several campaigns to pass budget overrides to maintain town services and rebuild Arlington's seven elementary schools. He is known for his support for the business community. In 1991, Kevin founded the Selectones, an ad hoc group of town officials who volunteer to sing at the senior center, public housing facilities, and local churches.

John (1951–2014) never held an elected position; however, he served the town as the general foreman for the department of public works and head dispatcher for the police department. Children loved visiting the station and getting his personal tours. John worked closely with police chief Fred Ryan to establish a reverse 911 system that telephones town residents to alert them to emergencies.

Brian (1955–2011) earned a master's degree in communication from Emerson College and taught at Suffolk University for nearly 30 years. He wrote creative pieces for the *Arlington Advocate*, penned humorous poems for family and friends, and developed campaign literature for local and state politicians. He was the communication officer for the county sheriff's office and worked for Bowes Real Estate. Brian helped the town to identify properties that could be used for affordable housing and in 2006 was appointed to the housing commission. The plaza at Cusack Terrace (elderly/disabled housing facility) is dedicated to him. Pictured here from left to right are Brian, John, Kevin, and Robert with their mother, Elizabeth. (Courtesy of the Greeley family.)

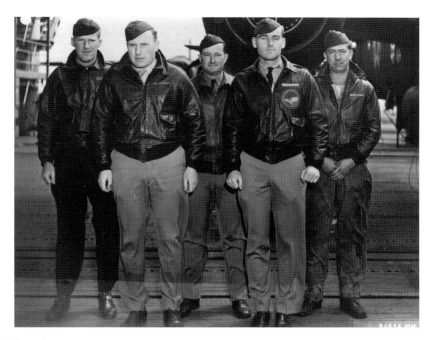

Howard Sessler

Howard Sessler graduated from Arlington High School in 1935 and entered military service five years later. He was one of 80 airmen who flew the first bombing raid over Tokyo in World War II in a group known as Doolittle's Raiders. Sessler was the navigator and bombardier on a mission considered extremely dangerous. Training involved learning how to take off within 300 feet, the available distance on their aircraft carrier, and practicing night flying and navigating without radio references or landmarks. Sessler's plane bombed a large aircraft factory before ditching in waters near China. The crew made it safely to shore. Sessler continued to serve throughout the war and afterward earned a degree in engineering and became president of a construction company. He died in 2001 at the age of 83. (Both, courtesy of Barbi Ennis Connolly.)

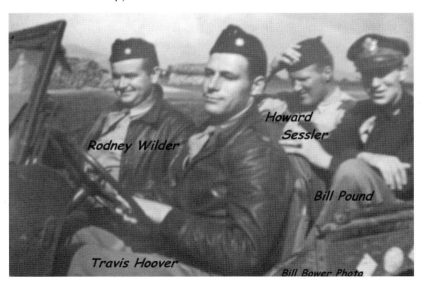

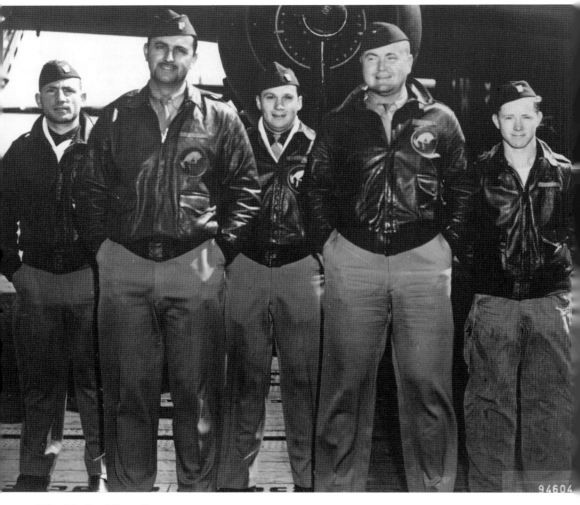

The McGurl Family
The McGurl family has a long and proud history of serving the United States. At a Veterans Day ceremony in 2009, the names of the 14 family members who fought in conflicts from World War I to Vietnam were read at the dedication of a plaque honoring Eugene McGurl, who died in World War II. Eugene was a member of the famed Doolittle Raiders, serving as a navigator on one of the flights that bombed Tokyo. He later died in a plane crash. He grew up on Grove Street, and his first cousin, Daniel, who grew up on Summer Street, played football at Arlington High School and was a rear gunner on a Flying Fortress. After seeing action at Midway and the Solomons, he died in a truck accident in 1943. (Courtesy of Barbi Ennis Connolly.)

Richard Howard Buzzell

Richard Howard Buzzell is one of eight Arlington residents whose names are on the Vietnam War Memorial in Washington, DC. Buzzell was 28 and a lieutenant junior grade in the US Navy when he was killed in An Xugen Province in South Vietnam. He served as a helicopter pilot. Buzzell was in the class of 1961 at Arlington High School, where he was manager of the hockey team. Buzzell Field is named for him. The other names on the wall are PFC Christopher Brine, Capt. Joseph Xavier Grant, SP5 Robert Tedford, Sgt. Glenn Hobart III, SP4 David Williams, SP4 Michael Camerlengo, and CDR John Leaver Jr. (Photograph by Marjorie Howard,)

Margaret Walsh Phaneuf

When a child has been injured due to war or terrorism, the Medical Mission Group can help. Founded by sisters Margaret Walsh Phaneuf and Maureen Walsh Bahou and their Arlington High School friend Carol Finlayson Bragg, the mission provides medical service in third-world countries. Bahou died in 2012, but Phaneuf continues the work. The missions have taken them to South America, Romania, and Central America along with a team of surgeons and anesthesiologists who perform reconstructive surgery. (Courtesy of Margaret Walsh Phaneuf.)

DEDICATED
IN MEMORY OF
ARLINGTON POLICE OFFICERS
WHO HAVE DIED
IN THE LINE OF DUTY.
GARRETT J. CODY JULY 1, 1901

WHAT LIES BEHIND US
AND WHAT LIES BEFORE US
ARE TINY MATTERS
COMPARED TO WHAT LIES WITHIN US.

Garrett Cody

On July 1, 1901, a fruit peddler came running into the police station after getting into an argument with a laborer who assaulted him with a knife. Officer Garrett Cody, 36, went to the scene, and when he arrived, the laborer was able to grab Cody's gun and shoot him in the head. Cody died at Massachusetts General Hospital. He had been with the police department for nine years and was the father of five children. His great-grandson Paul Higgins became a police officer with the Plymouth Police Department. Higgins said the death had had a lasting impact on his family, and on each tour of duty, he wears a memorial pin in recognition of his sacrifice. Cody and his family are pictured below. (Above, photograph by Marjorie Howard; below, courtesy of the Arlington Historical Society.)

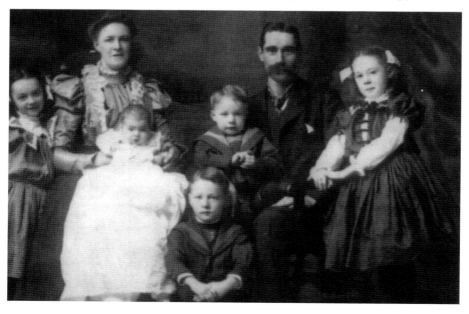

Alan McClennen

Mention projects that have enriched Arlington in the last 40 years, and most likely Alan McClennen was involved. He served as director of planning and community development from 1974 to 2003. During that time, he helped bring about improvements that many residents continue to enjoy. The Minuteman Bikeway, the renovation of Reid's Brook from a landfill to a park, and the creation of the Arlington Center for the Arts are perhaps the best known.

McClennen was instrumental in the formation of the bikeway, appropriately riding his bike to work each day and often to Boston for bikeway planning meetings. The 10-mile bikeway was built along the defunct Boston & Maine Railroad and was 20 years in the making. The bikeway (Minutemanbikeway.org) was dedicated to McClennen and Tom Fortmann of Lexington at its opening ceremony in 1993. In 2000, the bikeway was dedicated to Donald Marquis, who served 34 years as town manager and was also instrumental in the bikeway's completion.

McClennen was the force behind the town's purchase of Reid's Brook, a former landfill that was transformed into a park and named for him. He was behind an effort to transform the Gibbs School into other uses, one of which is the Arlington Center for the Arts. Each year, the center awards the Alan McClennen Community Arts Award to an individual or group who brings to life the center's mission of transforming lives and building community through the arts. Another accomplishment was the creation of Vision 2020 along with former town manager Don Marquis. The two hired a professional facilitator and got volunteers involved to help reactivate a citizen planning process. The program won a national award.

Now retired and living in Orleans, where he won election to the board of selectmen, McClennen credits others for helping Arlington becoming a thriving community after a population decline of some 20 percent. He cites Marquis, with whom he worked for 27 years, as well as a strong board of selectmen that included Arthur Saul, Harry McCabe, and Peg Spengler along with Ed Tsoi, who was on the redevelopment board. McClennen says these and other individuals were committed to sound planning and were willing to work with professionals from around the country to think about how to plan for a dense community of 5.5 square miles. (Courtesy of Alan McClennen.)

Patsy Kraemer
Kraemer worked for the Arlington Youth Consultation Center starting in 1970 as a volunteer and later as a paid social worker. In 1996, she was promoted to director of human services. Kraemer worked successfully to lower the rate of illegal drug use, teenage pregnancies, and instances of domestic abuse. She created programs to provide food, financial assistance, and fuel to needy families. She retired in 2006 after 36 years. (Photograph by Joey Walker.)

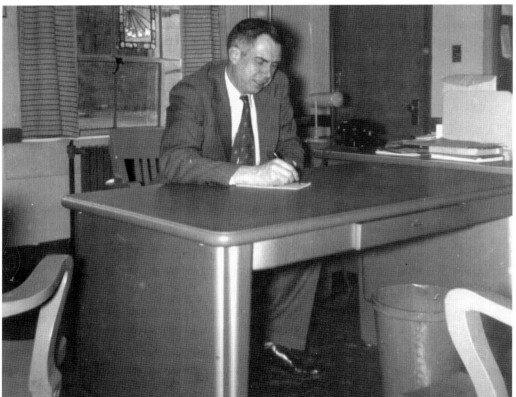

A. Henry Ottoson (1904–1972)
Henry Ottoson worked menial jobs so that he could graduate from Boston University with a degree in education. In 1939, he became the principal of the Junior High West in Arlington. Ottoson took a strong interest in his students, greeting each by name. He often visited the homes of those who got into trouble. Students enjoyed talking with him, and years later they would come to him for advice. The Ottoson Middle School was named for him. (Courtesy of the Ottoson family.)

Ann Mahon Powers

In 1959, just eight years after graduating from Arlington High School, Powers handily beat out seven men and was elected as Arlington's town clerk. In 1973, she was appointed to the board of selectmen, becoming the first woman to serve on that committee. Two years later, she was elected to that position and served two terms. In 1984, Powers was again elected as town clerk, and she retired in 1993. (Courtesy of the Arlington Board of Selectmen.)

Harry P. McCabe (1929–2014)

McCabe, an advocate for the old, the young, and the poor, was a selectman, town moderator, and for 48 years, a town meeting member. He was president of the Community Action Council, an anti-poverty program, and the senior association. McCabe served on numerous committees including 16 years on both the Arlington Housing Corporation and the Boys and Girls Club. McCabe received numerous awards for his service and was a mentor for those wanting to become involved in Arlington politics. (Courtesy of the Arlington Board of Selectmen.)

Charles Lyons, Barbara C. Goodman, and Allan Tosti

In 1998, Charlie Lyons (left), then chair of the board of selectmen, Barbara Goodman (center), chair of the school committee, and Al Tosti, chair of the finance committee, led the first successful campaign to raise property taxes in order to rebuild Arlington's seven elementary schools. The referendum question, approved by nearly 60 percent of the voters, authorized funding to rebuild or renovate the Brackett, Bishop, and Hardy Schools and develop plans for the remaining four schools. (Photograph by Bob Sprague.)

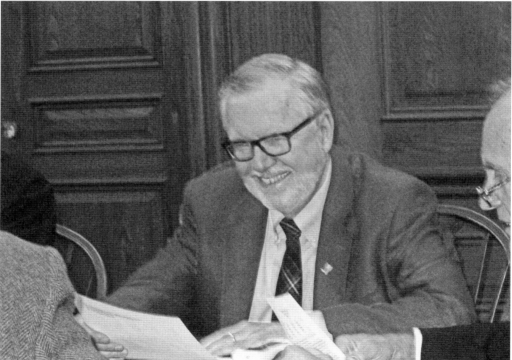

Charles T. "Charlie" Foskett

Since he moved to town in 1974, Foskett has worked to improve school facilities and advocated for a plan that financed rebuilding eight schools. He cochaired a successful referendum campaign that resulted in funding for four of these schools. As chair of the capital planning committee, Foskett initiated a five-year budget plan that consistently wins town meeting approval. He received the Rotary Club's Paul Harris Award for his contribution to the community. The Massachusetts Municipal Association has recognized his work, and he regularly presents at its conferences. (Photograph by Barbara C. Goodman.)

Kathleen F. "Kay" Donovan

The Arlington School Committee voted unanimously to appoint Kathleen Donovan to the position of superintendent of schools in the summer of 1994. She was charged with creating excellent schools and implementing an ambitious plan to reconstruct the middle school and all seven elementary school buildings.

Very early in her tenure, Donovan initiated a strategic planning process called "Our Children, Our Future, Our Plan." She brought hundreds of parents, teachers, community members, and town officials together to create a vision and blueprint for the future of Arlington schools. In accordance with the plan, she introduced technology into the schools, started full-day kindergarten, implemented an elementary Spanish program, and applied for and was awarded thousands of dollars in grants to provide professional development and revise curriculum. In 2005, when financing this plan was jeopardized by a loss of state aid, Donovan helped lead a successful campaign to raise the property taxes by $6 million to fund educational and other town programs.

Funding the reconstruction projects again required hard-fought campaigns to convince voters to increase their property taxes. Almost nightly for weeks, Donovan spoke passionately about the need to rebuild dilapidated school facilities and convinced residents that "for the price of a new pair of sneakers, we shall educate your children for a lifetime." Her energy, along with that of many others, led to winning two campaigns—one in 1998 and again in 2000. By the time she retired in 2005, Donovan had overseen the rebuilding of the middle school and five elementary schools.

Another challenge was the discovery of chemical pollutants in the field next to the high school. Donovan and other town officials spent years debating with the corporations that had once owned and contaminated the land. Kay Donovan persisted until they reached a negotiated settlement of $10 million not only to clean and mediate the property but also to provide artificial turf football and soccer fields, new ball fields, a basketball court, and bleachers. (Courtesy of Kay Donovan.)

Margaret "Peg" H. Spengler (1915–2002)

No one can explain how Margaret Spengler managed to accomplish so much. Spengler was the first woman elected to the board of selectman. She served two terms (1973–1979) and then in 1984 was appointed to serve an additional year. During the 57 years she lived in Arlington, Spengler worked on at least 25 town committees and commissions and chaired many of them. She was a library trustee, a member of the finance committee, the redevelopment board, and the permanent town building committee, and served on town meeting for 45 years. Spengler helped to establish the youth service commission and was cofounder of the Arlington League of Women Voters. Spengler chaired both Arlington's 350th anniversary celebration committee and the bicentennial celebration committee.

Four different governors—Democrats and Republicans—appointed her to various state boards and commissions, including the board of higher education. She also served as a trustee of state colleges.

Michael Dukakis, former Massachusetts governor, described Peg Spengler as "a political powerhouse, a person who called the shots, someone to ignore at one's own peril." In 1990, she headed the capital campaign to expand the Robbins Library. Even professional fundraisers thought her goal was too ambitious. Yet with large and small donations from private citizens, she raised the $500,000 that, combined with a state grant, was used to renovate and expand the library. Spengler Way, the entrance road to the library, is named in her honor. (Courtesy of Mark Spengler.)

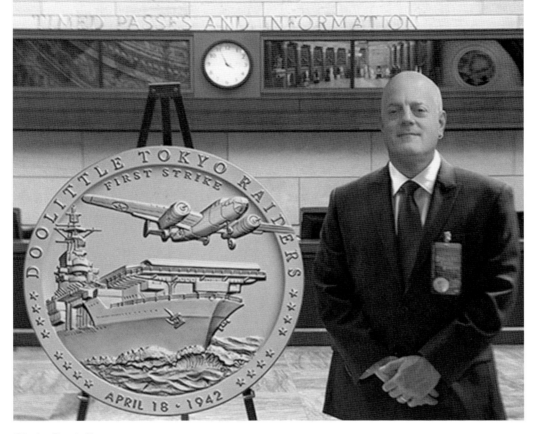

Chris Costello

Chris Costello has been a graphic designer and illustrator for 30 years, but one design in particular has a special meaning for him. In 2015, his design was chosen for a congressional medal honoring the Doolittle Raid over Japan in 1942. The raid was considered extremely dangerous, and its success demonstrated that the Japanese were vulnerable. Costello researched the raid, and while there were few restrictions about the design, it had to include the USS *Hornet* as well as a B-25B. The *Hornet* was the aircraft carrier from which the raid was launched. Costello said making the design and winning the competition was a privilege for him to be able to serve his country as an artist and honor the men involved. Costello is also a member of the board of the Dallin Museum. (Courtesy of Chris Costello.)

John L Worden III and Dr. Patricia Worden

The Wordens moved to Arlington in 1967 and quickly became involved in the community. John was elected to town meeting in 1970 and voted moderator in 1989. He was president of the Arlington Preservation Fund, the conservation association, and the Arlington Historical Society and an active member of numerous boards and commissions.

Patricia was a member and chairperson of the Arlington School Committee from 1979 to 1993 and also a member of the Arlington Housing Authority. She is a town meeting member, serving with perfect attendance from 1982 to 1988 and again from 1990 onward. Patricia was also a charter member of the human rights commission and the affordable housing task force. She has helped to increase Arlington's inventory of affordable housing. For nearly 45 years, the Wordens have worked to conserve open spaces and preserve Arlington's historical heritage. They have testified, written letters, devised bylaws, and formulated warrant articles. They were leaders in efforts to establish seven historical districts that have preserved 350 historical buildings and then helped create a loan program so that owners would have the funds to maintain their properties. The Wordens continue to fight to prevent developers from building on wetlands and demolishing notable homes. (Courtesy of the Wordens.)

John J. Bilafer

In 1983, John Bilafer, the town treasurer, petitioned the state legislature to allow Arlington to reformat its tax bills so that local taxpayers could, by simply checking a box, make voluntary contributions to a scholarship foundation. This program, Arlington Citizens' Scholarship Foundation, became a model for other municipalities. Soon, generous Arlington residents began to endow scholarships by donating a minimum of $10,000 to dedicated accounts established by the treasurer's office. In 1985, the first year of the program, four scholarships of $500 were granted. In 2014, over 60 students received awards through the check-off program; in addition, 31 endowed scholarships were given. The current value of the scholarship portfolio is $2.8 million. Bilafer also created two awards: his Arlington High School class of 1949 scholarship and the Bilafer/Kovich Family Scholarship. John Bilafer (left), Mary Ellen Bilafer, and John Kovich are pictured here with scholarship recipient John Ammondson. (Both, courtesy of John Bilafer.)

Marie Krepelka

Marie Krepelka is known as the "Mayor of Arlington." Since 1959, she has worked behind the scenes getting done whatever needed to be done. She has been the administrative assistant to five town managers, two building inspectors, and 30 selectmen. She is known for getting along with all of them. Krepelka is also called "Mother of Arlington." Every citizen who calls or comes into her office is made to feel welcome and that their concerns are important to her. If she cannot answer a question, she will always get back with the answer promptly.

Marie could have retired many years ago, but she loves her job and cares deeply about the town and its people, so she stays on. For her commitment to serving the public and for her work with numerous community groups, Marie earned an award from the chamber of commerce in 2003 and Rotary Community Person of the Year in 2010. (Courtesy of Marie Krepelka.)

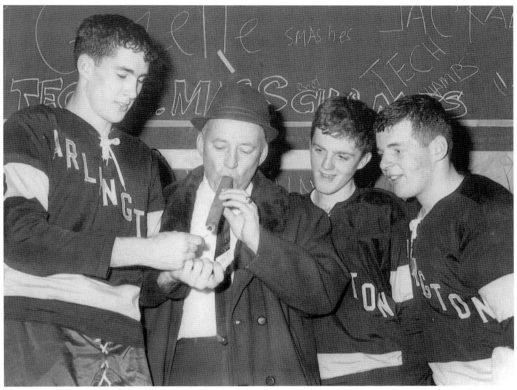

ED BURNS ARENA

NAMED IN HONOR OF OUR LEGENDARY COACH

HOCKEY 50 YEARS 1947-1997
28 LEAGUE CHAMPIONSHIPS
1 NEW ENGLAND CHAMPIONSHIP
5 STATE CHAMPIONSHIPS
3 EASTERN MASS CHAMPIONSHIPS

FOOTBALL 20 YEARS 1954-1974
5 LEAGUE CHAMPIONSHIPS
2 STATE CHAMPIONSHIPS

ADDITIONAL
MARINE, TEACHER, ADMINISTRATOR, ATHLETIC DIRECTOR

BOSTON COLLEGE HALL OF FAME (1987)
U.S. HOCKEY HALL OF FAME (1976)
MASS HOCKEY HALL OF FAME (1998)
MASS FOOTBALL HALL OF FAME (1979)
BOSTON GARDEN 60TH ANNIVERSARY CELEBRATION (1988)
AMERICAN HOCKEY COACHES MARIUCCI AWARD (1989)
HARTFORD WHALERS OUTSTANDING SERVICE AWARD (1990)
ARLINGTON HIGH SPORTS HALL OF FAME (1992)
MIAA DISTINGUISHED SERVICE AWARD (1992)

Ed Burns

A sports star in high school, Ed Burns was the only sophomore on the Arlington High School 1937 football team, eventually becoming its captain. He also played three years of varsity hockey and in the spring split his time between baseball and swimming. He went on to a stellar coaching career at his alma mater, serving as both football and hockey coach. When Burns retired in 1997 after a 50-year career, he had coached 1,108 games and won 805 of them, 695 in hockey. He had just one losing season and won five state titles. Burns was inducted into the US Hockey Hall of Fame (1976), the Massachusetts Football Hall of Fame (1979), and the National High School Sports Hall of Fame (1992), where he is one of only three inductees from Massachusetts. He was in the first class of the Arlington High School Hall of Fame (1991). The town skating rink on Summer Street was named in his honor and is known as the Ed Burns Arena. He died in 2014. (Above, courtesy of Joe Bertagna; left, photograph by Marjorie Howard.)

Daniel J. Shine
Daniel J. Shine, director of athletics for Arlington Catholic High School, has been head coach of the boys' ice hockey team for 37 years. In 2014, he became a member of the 500-win club. Shine received the coach of the year award from the *Boston Globe* and the *Boston Herald* in 1990 and 1997 and the Athletic Director of the Year award from the Massachusetts Athletic Director's Association in 2014. (Courtesy of Arlington Catholic High School.)

Richard DeCaprio
Richard DeCaprio was a teacher and administrator in the Arlington Public Schools for nearly 40 years. A 1964 graduate of Arlington High School, he played hockey under the legendary Eddie Burns and, after serving as an assistant coach in football and ice hockey, succeeded Burns as head coach in 1997. Because of his stellar performance as coach and his contributions to high school hockey, he was inducted into the Massachusetts State Hockey Coaches Association's Hall of Fame as both a referee and a coach. He played hockey at Boston University and later served as an assistant coach at the University of Massachusetts at Lowell and as a scout for the St. Louis Blues. He is a member of the Arlington High School Hall of Fame. (Courtesy of Hockey East.)

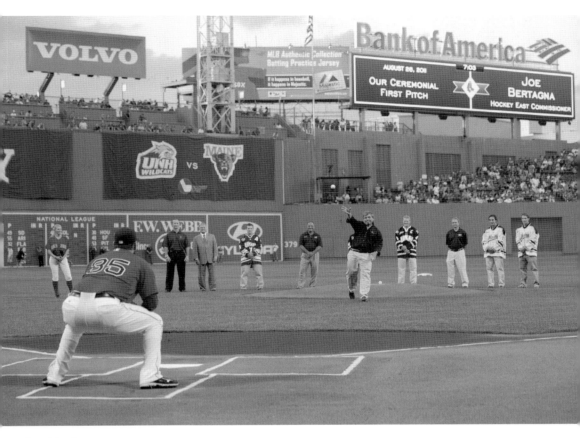

Joe Bertagna

Joe Bertagna began his life in hockey under the tutelage of coach Ed Burns at Arlington High School. He went on to play at Harvard and today is an influential goalie coach and administrator. He has been commissioner of Hockey East for more than 30 years and is credited with vastly increasing game attendance as well as media coverage. His coaching career has taken him to the Olympics, the Boston Bruins, and to Harvard. He was instrumental in forming the Women's Hockey East Association, which recognized his contributions to women's hockey by naming its trophy the Bertagna Trophy. He was the first head coach of Harvard University's women's ice hockey team. He helped organize the first outdoor college hockey game in the East, held at Fenway Park in 2010. (Courtesy of Joe Bertagna.)

Victoria "Vicki" Rose

Menotomy Manor is the home to the largest population of low-income residents in Arlington and houses families from many different linguistic and ethnic backgrounds. Vicki Rose and her husband, Brian, raised their four children there, and for the past two decades, Vicki has found numerous ways to reach out and connect the other residents to the nearby Thompson Public School and the larger Arlington community.

First as the Thompson School's community liaison and parent-outreach coordinator and now as the school's administrative assistant, Vicki has worked to ensure that parents in Menotomy Manor understood how to access school resources and communicate with teachers and the administrators. Vicki helped to establish a homework-support program for students, a holiday help program at Christmas, and a Thanksgiving food basket distribution in November.

In a creative effort to connect families in Menotomy Manor to healthy food at low prices, Vicki and longtime friend Leon Cantor began a "seconds market," wherein unsold produce from the farmers' market is distributed directly to Menotomy Manor residents at bargain basement prices.

Vicki cofounded a nonprofit corporation called Arlington EATS (Arlington Students Eat All Through the Summer) so that low-income students would have access to healthy meals when school is closed. Vicki also manages a snack program so that students who are hungry can choose a piece of fruit or a healthy snack during the school day. Over 400 snacks are distributed weekly.

Vicki also links families that need other items such as clothes, gift cards to grocery stores, and school supplies to community partners that make the appropriate donations. Vicki knows the families so well that when contributions of baby items, clothing, or food cards come in, she knows just who could use them.

Vicki also reached out to Arlington High School students in the Do Something Club, who cook hot meals for some of the families. She personally delivers eight dinners a week.

Vicki is deeply committed to the community and understands the issues her neighbors face. For her selfless dedication, Vicki earned the 2015 Massachusetts Commission on the Status of Women's Unsung Heroine award. (Courtesy of Victoria Rose.)

Julia Morrison (1924–2015)

For 50 years, starting in 1957, Julia Morrison, the school crossing guard, helped generations of students and families traverse Eastern Avenue on their way to and from the Brackett School. The jubilee of the woman known as the "Queen of Eastern Avenue" was celebrated in 2007.

Always immaculately dressed and groomed, wearing white gloves, she greeted each student with a huge smile and a twinkle in her eye. She freely gave out hugs and candy.

Morrison never left her post until all the children were safe in school or on their way home, no matter if it was raining, snowing, or the temperature was below zero. She even made sure that dogs that had followed the children to school were returned to their owners rather than the animal-control officer.

Children loved Morrison and dedicated poems and songs to her. Parents trusted that their children would be in safe hands. In recognition of her service, the town dedicated her crosswalk Mrs. Morrison Way, pictured at right. (Above, courtesy of the *Arlington Advocate*; right, photograph by Barbara C. Goodman.)

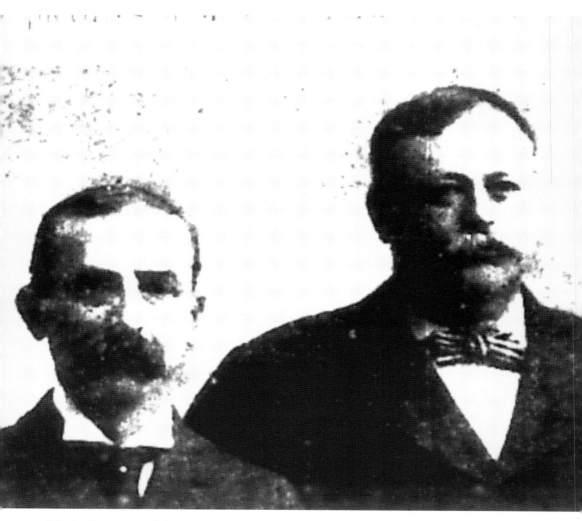

Edwin Farmer and George Doe

According to the *Arlington Advocate* on May 11, 1901, these men "neglected private business affairs and worked night and day to unravel the snarl in which the town finances have been allowed to drift."

In April, a mysterious fire in town hall led to the discovery that money and the treasurer's cashbook were missing from the safe. Then a Water Street sewer pipe, clogged and stuffed with town bills and receipts, flowed straight from the home of Ronald Swan, the assistant town clerk/treasurer.

The search for the missing cashbook led Police Chief Harriman to Swan's friend Mrs. Lawson (a woman with two living husbands), who seemed to make the cash book mysteriously reappear.

The loss to the town was about $30,000. Swan pled guilty to 280 counts of larceny and was sentenced to 8 to 10 years in prison. (Courtesy of the *Arlington Advocate*.)

CHAPTER FIVE

Business

John Cullinane was a Northeastern University student in the 1950s, getting work experience with a co-op at the consulting firm Arthur D. Little. His office was adjacent to the company's big bulky Burroughs computer, and the young Cullinane was fascinated. The next year, he managed to work on that computer, and a career was born. Cullinane went on to found the first company to sell software as a standalone product.

Arlington entrepreneurs have been successful in a variety of endeavors, whether developing innovative solutions or building businesses both big and small.

One of the earliest successful businessmen to have an impact in Arlington was Frederic Tudor. He did not live in Arlington but developed Spy Pond into a business venture, harvesting its ice—for free—and sending it around the world, packed in sawdust. While ice made food preservation possible, it also created the demand for a frosty drink. Harvard Business School reportedly saluted Tudor as an example of someone who created a demand for a product that had not existed before.

Some of Arlington's business successes have been in a large arena. Rick Kelleher is chief executive officer of the Pyramid Hotel Group, which has 55 properties and more than 19,000 rooms in the United States and the Caribbean. Other successful entrepreneurs operate on a smaller but no less necessary scale. For decades, shoppers in need have turned to Balich, a five-and-dime variety store that stocks everything from shoe polish to the latest kids' candy craze.

Arlington is unusual in having three hardware stores, all dating back many years. Shattuck's, Wanamaker's, and Arlington Coal and Lumber keep home owners and do-it-yourselfers well supplied. In the winter they are the go-to places for snow shovels and rock salt.

The town is also unusual in having three main shopping areas: East Arlington, with its theater and funky shops; the Center, the mainstay of the town; and Arlington Heights. Each offers a range of local businesses, so there is little need to leave town to shop or dine.

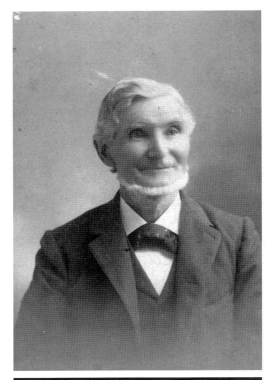

Charles and Frederick Schwamb
In 1864, Charles (above) and Frederick Schwamb purchased property on Mill Lane and began to manufacture oval and circular picture frames. Charles and Frederick were two of six brothers who immigrated to America from Germany between 1838 and 1857. Their mill, now a living history museum, became known for black walnut oval frames. The Schwambs saw a market for frames that would handsomely set off portraits, which were becoming increasingly popular as photography became more accessible. Situated along the Mill Brook, the brothers' enterprise had, since the late 1600s, been the site of mills for grinding corn and spices. During the 1870s, the largest workforce numbered 35 to 40 men. Over time, three sources of power drove the mill's machines: water from 1864 to the mid-1880s, steam from the mid-1880s to late 1948, and now electricity. The building is the site of the oldest continuously operating mill in the United States. Pictured below is Patricia Fitzmaurice. (Both, courtesy of the Old Schwamb Mill.)

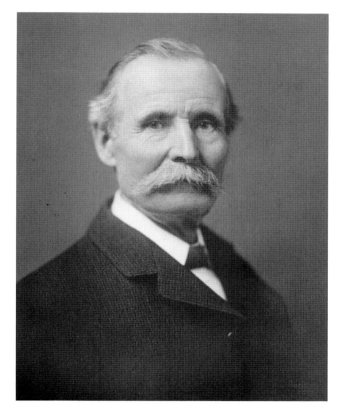

Theodore Schwamb
Between 1838 and 1857, six Schwamb brothers came from Germany to Boston to learn woodworking. Five brothers—Jacob, Karl (later Charles), Peter, Theodore (above), and Frederick—arrived in Arlington Heights between 1850 and 1862. The Mill Brook powered mills of various kinds at seven to nine millsites. The brothers established three mills along the brook from Brattle Square in the east to Mill Lane in the west. Jacob built his mill east of the corner of Brattle Street at 1033 Massachusetts Avenue.

Theodore owned a building at 1165 Massachusetts Avenue that included a private railroad spur for the delivery of wood for the piano cases he manufactured. As recordings and the radio grew popular in the first part of the 20th century, piano sales diminished. The business went out of the family in 1931, though it retained the name and continued to produce the finest wood trim for universities, estates, and public buildings until it was closed in 1972. When the Theodore Schwamb Mill closed the property, it was acquired by another immigrant entrepreneur, John P. Mirak, in part for use by his automobile dealership and also to lease to small businesses. The Mirak family has been an excellent steward of the buildings.

The Old Schwamb Mill, operated by Charles and Frederick, was listed in the National Register of Historic Places by the US Department of the Interior because of the mill's national historical significance. The site of the Old Schwamb Mill is now the longest continuously operating millsite in the United States. The earlier mills are either long gone or no longer operating. Schwamb frames and moldings are in major art museums and included in the collections of the White House, the Vatican, Buckingham Palace, the Palace of the Kings of Hawaii, and the collection of Queen Sylvia of Sweden.

After being acquired by the Schwamb Mill Preservation Trust, the Old Schwamb Mill continues to manufacture museum-quality frames and receives additional income from donors and tenants. The mill still produces heirloom round and oval frames of the highest quality. (Courtesy of the Old Schwamb Mill.)

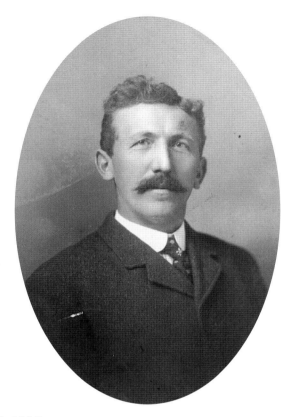

Jacob Bitzer (1865–1946)

With his mother and sister, Jacob Bitzer arrived in Arlington from Wurttemburg, Germany, at the age of eight to join his father and brother, who had already established themselves in Arlington. The Bitzer men worked for both Charles and Theodore Schwamb, and their woodworking and technological expertise was well regarded. The young Jacob Bitzer finished his schooling in Arlington Heights at the Cutter School, and then he apprenticed for six years at the Welch and Griffiths Saw Manufactory on Grove Street. After that firm failed, 20-year-old Bitzer moved to Theodore Shwamb's piano-case manufacturing plant, eventually working his way up to assistant superintendent in charge of the mill department.

The growing prosperity of Theodore Schwamb's piano-case manufacturing business allowed the company to double its land holdings, add a spur line to the nearby railroad, build out more shop space, and hire a larger workforce. Pianos were nearly a requirement in every middle-class home at the turn of the 20th century, and the Theodore Schwamb Company provided cases for many of them. By 1897, when the Schwamb Company incorporated, Jacob Bitzer was a stockholder and clerk of the corporation.

In 1906, Jacob Bitzer added to his real estate holdings in Arlington Heights by purchasing the Charles Schwamb estate for his home. Successful in local politics as well, Bitzer was a member of the influential Committee of Twenty-One, chairman of the Republican town committee and national delegate in 1914, a popular selectman from 1910 to 1914, and, later, town meeting moderator. He was the chairman of the high school and Brackett School building committees. This German immigrant served as state representative from the 27th Middlesex District from 1915 to 1919. In the 1914 election, one of his defeated opponents was the noted sculptor Cyrus Dallin, campaigning as a member of the short-lived Progressive Party. As a legislator, Bitzer championed the building of the Mystic Valley Parkway, convincing the town to dump enough Mount Pleasant Cemetery gravel onto the swampy land to provide a sturdy roadbed—his most lasting legacy. (Courtesy of the Old Schwamb Mill.)

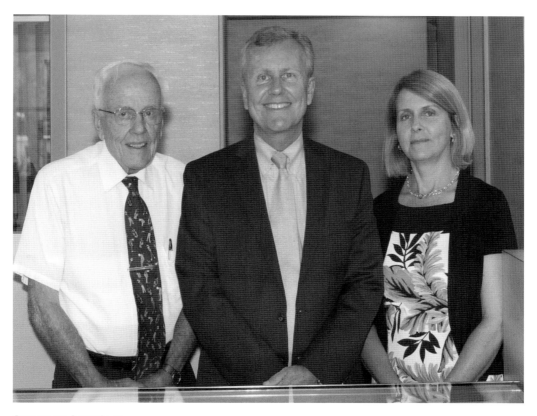

Swanson Jewelers

After being punished for being late to school in Sweden, Carl Swanson decided punctuality was important, so when he came to the United States, he was determined to have his own watch company. He opened his store on Massachusetts Avenue in 1938. Carl's son Bob joined the business, as have grandchildren David and Karen. In addition to watches, the store sells fine jewelry and diamonds. (Photograph by Joey Walker.)

Sanford Camera

Boston Globe and *Boston Herald* photographers take their cameras to Sanford Camera for repairs, as do plenty of amateurs. Jerry Sanford moved the store from Brighton to Arlington in 1970. His son Paul took over the business in 2013 when Jerry died at 94. The two saw many changes in cameras over the years, including the switch to digital and cell phone cameras, keeping up with changes as they have arrived. (Courtesy of Sanford Camera.)

R.W. Shattuck (1830–1898)

Shattuck's Hardware has been a family-owned store since 1857. R.W. started it in the basement of his house in West Medford and relocated to Arlington a few years later. In 1936, it moved to 440–446 Massachusetts Avenue in Arlington Center and remained there for about 50 years. The store was a social gathering place on Saturday nights. Shattuck's family home still stands at 274–275 Broadway. Legend has it that because he was the youngest of six children, Shattuck's parents never got around to naming him. When taken to buy his first pair of shoes, the store owner asked his name. When told he did not have one, the merchant offered his family a free pair of shoes if he took his name—Ralph Warren—thus becoming R.W. Shattuck. (Both, courtesy of the Arlington Historical Society.)

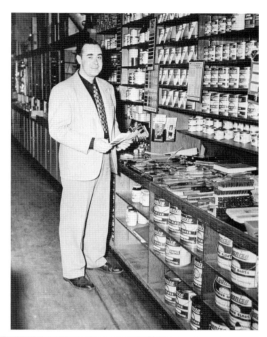

John Wanamaker

Wanamaker Hardware has been in Arlington Heights since 1923, when Chester and Marion Wanamaker opened C.K. Wanamaker. Their son John took over the business as a young man with the help of longtime store manager Gerald Morgan. Today the third generation, John's sons, Mark and John, operate the current store, which has been at its present site since 1953. Mark Wanamaker has watched the advent of computers make keeping track of inventory easier and consumers choose to replace items instead of fixing them. (Courtesy of Mark Wanamaker.)

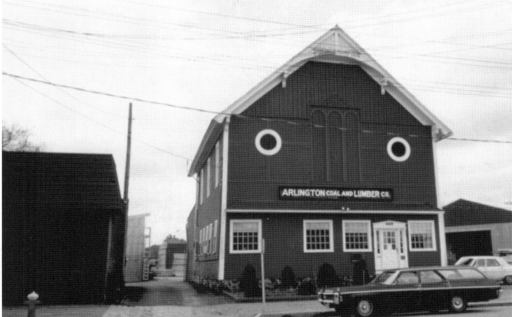

Arlington Coal and Lumber

When the Arlington Coal Company was founded in 1914, coal shipments would arrive by the Boston & Maine Railroad and were loaded into a coal chute. Customers still recall sliding down the chutes as children. The chutes were destroyed in a fire in 1951. The McNamara family bought the company in 1959, and the name Arlington Coal and Lumber reflects the emphasis on lumber and building materials. (Courtesy of the Arlington Historical Society.)

Kay and Peter Jorgensen

Little did Kay Jorgensen think when she enrolled at Boston University that a master's program would change her life, but it did. That is where she met her husband, Pete, who had grown up in Arlington on Crosby Street. The two embarked on a publishing career, buying the *Arlington Advocate* in 1969. By 1986, when they sold their company, Century Publications, they were publishing six suburban weekly newspapers, including the *Winchester Star* and the *Belmont Citizen*. In the mid-1970s, the couple also published newspapers in Vermont, New Hampshire, and New York.

As publishers—as well as reporters, editors, and photographers—they often worked around the clock, covering fires, police news, town government, and stories about Arlington's citizens. In fact, they lived above the store, having bought a historic house on Water Street that served as the *Advocate*'s offices downstairs and their home upstairs.

The couple built the *Advocate*'s circulation up from 7,000 to 12,000, along the way discovering they owned a paper in a town not used to being covered by reporters. Kay used to carry a copy of the state's open meeting law in her pocket because boards and commissions often would not let her attend their sessions. Over time, the town grew used to coverage of local politics and sports; townspeople learned that if something of interest happened it was going to be in the paper.

The Jorgensens worked hard but also had a lot of fun, and the papers served as a training ground for young reporters who went on to journalism careers, having learned at the *Advocate* how to write headlines, edit copy, do interviews, lay out pages, and write captions. Pete did not want what he called "weakly editorials," so the paper ran editorials only four or five times a year and then always on the front page.

Kay and Pete were in their 20s when they bought the *Arlington Advocate*, and eventually Kay said if a good offer came along they would take it, as working seven days a week and covering night meetings was becoming challenging. So in 1986, they sold the paper to Harte Hanks and moved to Vermont. There they pursued Pete's longtime interest in the Civil War and published *Civil War News*, among other publications. Pete died in 2009 at the age of 68, and Kay remains publisher. (Courtesy of Kay Jorgensen.)

Charles S. Parker

Charles Symmes Parker (1839–1928) was the founding editor and publisher of the *Arlington Advocate* for more than 50 years. He served in the Civil War, enlisting as a private in 1865 and serving in Company B of the 11th Regimental Infantry of Massachusetts Volunteers. He alternated as a hospital orderly on the battlefront and as a musician. In 1907, he wrote a book about Arlington history called *History of Arlington, Past and Present, a Narrative of Larger Events and Important Changes in the Village Precinct and Town from 1637 to 1907.* (Courtesy of the Arlington Historical Society.)

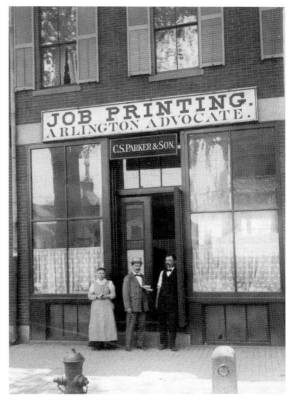

Bob Sprague

Bob Sprague has had a long career in journalism, including serving as editor of the *Arlington Advocate* along with stints at the *Boston Globe* and the *Boston Herald.* In 2006, he left print behind to publish yourarlington.com, a website that focuses on local news, community events, restaurant and movie reviews, and Arlington's people. Sprague takes pride in keeping the community informed soon after events take place. He enjoys scooping other media, and the *Globe* often relies on his reporting. (Photograph by Marjorie Howard.)

Collins' Corner
by Leonard Collins
Jan 27 1972

Bringing Up Grindstones

The word "moonlighting" has been associated with many jobs, and especially those who are commonly known as our municipal employes ... to the writer this is fine, and they show an interest in the welfare of ...lies. Maybe we don't pay them enough, but the fact remains one ...many places of business and see firemen, policemen, mail ...hers, and so many more doing a little bit of extra ...duties are finished. ...paint houses, officiate at sports event ...rodding to get them set to go on ...rs, to the writer, make ... is true. ... are the ones ... thei

Leonard W. Collins (1896–1982)

Leonard Collins, selectman and historian of all things Arlington, wrote for the *Arlington Advocate*. His column, Collins Corner, ran weekly for 15 years. Leonard played semiprofessional baseball, coached local teams, and served as an umpire for college games. He claimed to have attended 30 colleges—each for nine innings. In his memory, a plaque designates the intersection of Mass Avenue and Schouler Court as Collins Corner. (Courtesy of the *Arlington Advocate*, October 2009.)

Bob Bowes

Since 1977, realtor Frank Bowes and his son Bob have made sure a Christmas dinner is provided for anyone who would otherwise be alone on Christmas Day. Frank began the custom in 1977, and the dinner is always held at the Arlington Lodge of Elks on Pond Lane, which donates the space. Volunteers cook the meal, provided by Bowes, who also makes sure there is transportation. In the early years, some 90 people would attend; more recently the number has diminished to 30 as more services are available to the elderly, who make up the majority of the diners. But there have also been college students unable to make it home for the holidays and a young woman whose car broke down. (Courtesy of Bob Bowes.)

Richard M. "Rick" Kelleher

Richard M. Kelleher (right) graduated from Arlington High School in 1967 and went on to become a leader in the hospitality industry. Better known as Rick, he serves as the chief executive officer and principal of the Pyramid Hotel Group, LLC. The company owns 55 properties with more than 19,000 rooms as well as 15 spas and nine golf courses and operates such nationally known hotels as Marriott, Hyatt, Hilton, and Starwood. Locally, the holdings Kelleher oversees include the famed Boston Harbor Hotel.

Kelleher cofounded Beacon Hotel Corporation in 1983, directing the acquisition of Guest Quarters Suite Hotels and Doubletree Hotels, among others. The company merged with another hotel corporation, and its holdings included Embassy Suites, Hampton Inn, and Homewood Suites.

Kelleher has served on the board of directors of numerous organizations, including the Sports Legacy Institute, which aims to advance the treatment and prevention of brain trauma in athletes. In 2008, his wife, Nancy, was diagnosed with breast cancer. The couple has been generous donors to a number of programs involving research aimed at helping to increase early detection of breast cancer to improve survival rates. The Boston Harbor Hotel often hosts major fundraising events for breast cancer. In 2011, the couple received the Boston Humanitarian Award. (Courtesy of Richard Kelleher.)

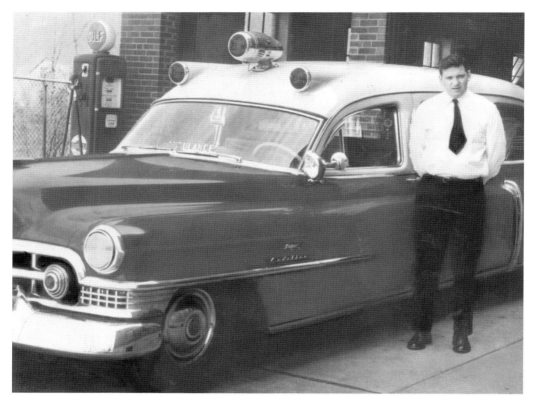

Bill Armstrong

Fresh out of the Marines in 1946 and back home in Arlington, Bill Armstrong helped out a neighbor by driving him to Massachusetts General Hospital for daily treatments. Armstrong would wait in the lobby, where he watched ambulances discharging sick and injured patients, and decided this would be his career. He bought a Cadillac ambulance, and with help from his mother, who cashed in an insurance policy, he and a partner formed the Arlington Ambulance Service, which began its service out of the family home. Later, the partner left the business, and the company was renamed Armstrong Ambulance.

In those early years, Armstrong slept in his ambulance by a pay phone, waiting for calls from the police, to whom he had given his phone number. A family member or neighbor would ride as his assistant on night calls. He began buying more vehicles and hiring more staff and took pains to make sure every detail was in place: there were extra socks on board the ambulances to keep patients' feet warm as well as extra blankets and even a towel to cover a patient's head if it was raining.

With no regulations governing the ambulance business, Armstrong helped establish the Massachusetts Ambulance Association, which ensures that state standards are followed by all providers. He was also a pioneer in the field of advanced life support. Armstrong Ambulance now has a fleet of nearly 100 vehicles and 300 employees and serves more than 100,000 people in Eastern Massachusetts. Armstrong was known for his philanthropy, supporting police and fire departments with training and medical equipment, helping schools, and providing scholarship money to high school students. He also provided numerous acts of private charity, aiding a school child who needed dental work or a nursing home that needed a television or the wife of a patient who needed help with daily expenses. As his company grew, he would always ask employees and visitors, "What do you think is the one thing that you need to have to work for me?" The answer was, "Compassion." (Courtesy of Armstrong Ambulance.)

John Mirak

John Mirak (left), pictured here with Lew Warsky, was the sole survivor of a massacre during the Armenian Genocide of 1915. Left an orphan at the age of eight, he came to America at 14, eventually becoming a successful businessman and philanthropist.

Born Zaven Mirakian in 1907, he married Artemis Eramian, also a genocide survivor. Together they raised a family of four children, Robert, Charles, Edward, and Muriel. In 1935, he and a group of partners entered the truck-leasing business and bought a garage at 440 Massachusetts Avenue and a Chevrolet dealership. After the war, he expanded into real estate and built a showroom for automobiles on Massachusetts Avenue.

In 1953, college freshman Charlie, better known as Sooky, was paralyzed in a car accident. The family bought a lot on Morningside Drive and built a single-story home so he would have wheelchair access to all the rooms. Sooky eventually went on to work in his father's business, becoming the financial and personnel manager.

John continued to expand his businesses, purchasing a Boston building that he converted into offices and building an apartment complex in Boston. He added a car-rental franchise at Logan Airport and a car dealership in Winthrop operated by his son Edward, who later became the principal dealer at Mirak Chevrolet. Bob, a historian who earned his doctorate from Harvard, wrote a book about Armenians in America. He left a teaching career to work in the real estate arm of the family business. Muriel Mirak-Weisbach is a scholar and journalist involved in international humanitarian efforts.

In the 1980s, John consolidated his acquisitions in Arlington Heights and built a new Mirak Chevrolet dealership that opened in 1984. Mirak made generous donations to Arlington and to the Armenian community and served on numerous boards. He donated the reading room at Robbins Library and the Jefferson Cutter House. He served on the Symmes Hospital board and was generous to such local organizations as the Boys and Girls Club. Mirak was the benefactor to numerous Armenian groups, finding a home in Arlington for the Armenian Cultural Foundation and helping to finance the institution through his foundation. He died in 2000. Known for his hard work, early on he put in 20-hour days. Bob thinks his father's interest in land and developing buildings stemmed from his need for roots, something he had lost as a child. (Courtesy of Bob Mirak.)

The Balich Family

"If you don't know where else to find it, try Balich." That has been the word around town for more than 40 years, as four generations of the Balich family operate their five-and-dime, helping customers find everything from a pair of socks to a rubber chicken. Household items, gloves, and sewing and knitting supplies as well as stationery and notebooks are among the wares; kids happily wander along the toy aisle and hover up front, where there is a plentiful supply of candy.

Joe Balich took over the store from his parents, Antoun and Gloria, and now grandson Reed helps out. The Arlington Heights store has stayed in business since Antoun took over in 1972 from Ralph Hudson, who opened his five-and-dime in 1954 and had a second spot across from the Capitol Theatre. Antoun, an immigrant from Syria, had owned a Dorchester convenience store before buying the store and moving with his family to Arlington.

Joe has worked at the store since 1984 after gaining retail experience with CVS. Customers know he can quickly find anything in the well-stocked aisles. Pictured here are Antoun and Gloria in front and Reed and Joe in the back. (Photograph by Bob Sprague.)

Albert and John Casey

Albert Casey (pictured) and his brother, John, were the heads of two major airlines at the same time. Albert led American Airlines out of financial difficulty during a time of deregulation and competition. The year before he left the airline, it reported its largest profit in the company's history. He also served as postmaster general and president of the *Times Mirror*, leading the company to diversify and acquire cable television properties, television stations, and books and magazines. His book *Casey's Law: If Something Can Go Right It Should* espoused his positive attitude and also encouraged hard work and belief in employees. John's entire career was in aviation. He was a test pilot in World War II, and his assignment included command of the transport squadron of the Manhattan Project, which developed the first atomic bomb. He took over Braniff Airlines in 1981 and later ran Pan American Airways. Known for his financial acumen, Al was named in 1991 to manage the Resolution Trust Corporation, which managed failed savings and loan institutions. He was known as personable, paying as much attention to baggage handlers as he did to pilots. John was considered one of the top operations experts in the airline industry. When he was named to Braniff, the teasing younger brother was said to have wished him success, noting he did not want him as a dependent. (Courtesy of the American Airlines CR Smith Museum.)

John Cullinane

In 1968, John Cullinane did something no one else had been able to do: he began selling software on its own, thus founding the first standalone software company. Before the Cullinane Corporation began selling software packages, companies developed their own software or it came along with the hardware. Cullinane Corporation, later known as Cullinet, went on to grow at a rate of 50 percent annually for 13 consecutive years and was the first software company to be listed on the New York Stock Exchange.

Cullinane's introduction to the computer came when he was a student co-op at Northeastern University in the 1950s at the Arthur D. Little Company in an office next door to a Burroughs 205, the first commercially available computer. As a software pioneer, he has won numerous awards, including the Commonwealth Award from the Massachusetts Technology Leadership Council and the first honorary degree awarded outside Ireland by the University of Ulster for his work helping the peace process in Northern Ireland through jobs. He was inducted into the Babson College Academy of Distinguished Entrepreneurs and the Infomart Information Processing Hall of Fame. He created the Boston Public Library Foundation, was the first president of the John F. Kennedy Library Foundation, and founded the Friends of Belfast. He also was a member of the Aspen Institute's Middle East Strategy Group. Cullinane is author of *Smarter Than Their Machines: Oral Histories of Pioneers in Interactive Computing*, in which he weaves together accounts of some of the key innovators in the world of computers and computer science, providing a lively history of an industry that has changed the world. (Courtesy of Craig Bailey, Northeastern University.)

CHAPTER SIX

Notables

Some of Arlington's best known residents were born and grew up here, while others were attracted by its convenient location, parks, and schools. Celebrities, academics, and even a Nobel Prize winner have called Arlington home.

Olympia Dukakis, who won an Academy Award for her role in *Moonstruck*, went to Arlington High School, as did comedian and actor Dane Cook. David-Allen Ryan, better known as Chico Ryan, was born in Arlington and sang with Sha Na Na, the group that celebrated 1950s rock 'n' roll. Johnny Kelley raised his arms in triumph after each of his record-breaking 61 Boston Marathon runs. Kelley got his training in before and after his job at Boston Edison.

Others chose to move here and stayed on. Mildred Dresselhaus, a scientist who was awarded the Presidential Medal of Freedom in 2014, moved to Arlington early in her career with her husband, Gene, also a physicist, when the two were hired by Lincoln Labs and later MIT. The location was perfect, and they made the town their permanent home.

Others in academia have been drawn to Arlington. Hilary Putnam taught at Harvard for more than 30 years, while Roy Glauber, who won the Nobel Prize in physics in 2005, taught at MIT. J.C.R. Licklider also taught at MIT. His ideas led to the creation of the Internet, and he predicted the use of computer networks as tools for communication. George Franklin Grant was the first African American professor at Harvard, teaching in the dental school after earning his degree. Bob Frankston is the cocreator of the first spreadsheet program, and Ron Rivest made commercial Internet transactions possible by developing an algorithm that keeps them safe and secure.

And while Tom and Ray Magliozzi, better known as Click and Clack, often referred to Cambridge as "Our Fair City" in their radio show *Car Talk*, they spent plenty of time in the fair town of Arlington.

Mildred Spiewak Dresselhaus

For decades, Mildred Spiewak Dresselhaus has arrived at her office at MIT by 5:30 a.m., ready to begin a day filled with teaching and research. Born in 1930, Dresselhaus is professor emerita of physics and electrical engineering. Her groundbreaking research on carbon and its properties paved the way for nanotechnology, the ability to see and control individual atoms and molecules.

The woman dubbed the "Queen of Carbon Science" is also known for encouraging young women who chose to study physics, meeting daily for 45 years with small groups of women to provide support. But her help for all students is legendary. When she was in Washington, serving in the Department of Energy, she flew home each weekend to meet with students, and over the years, many have said she inspired them in their studies.

Her own background was challenging. Her parents were Polish immigrants, and her father had trouble finding work, so she grew up poor in the Bronx. She excelled in school but thought the only jobs open to women were teaching, nursing, and secretarial work. She planned to teach until she took a physics course at Hunter College with Rosalyn Yalow, who would later win a Nobel Prize. Yalow recognized her abilities and persuaded her to focus on science.

At the University of Chicago, her advisor told her women had no place in science. Nevertheless, she earned her doctorate and married physicist Gene Dresselhaus. Both began teaching at MIT in the 1960s, one of the only places that would hire a married couple.

She and her husband raised a family of four children, and she says she managed to have a career and a family with the help of a longtime babysitter whose connection to the family, in turn, made college possible for her own children.

In 2014, Dresselhaus was awarded the Presidential Medal of Freedom by President Obama, and she has won numerous other prizes, including 28 honorary degrees and the $1-million Kavli Prize. She donated the money to MIT to support women or junior faculty. Somehow, in her spare time, she managed to find time to play violin and viola in music groups and continues to play daily. (Photograph by Knut Falch, courtesy of the Norwegian Academy of Science and Letters.)

George Franklin Grant

The son of a runaway slave, George Franklin Grant (1847–1910) was the first African American faculty member of Harvard University and the second African American to graduate from Harvard Dental School. He also loved to play golf, but he hated what happened when he played during lunchtime. Whenever he teed off, he would have to build a mound of dirt or sand to hold the ball and return to his patients with dirty hands. So he invented not the golf tee itself but a device to improve it.

Grant grew up in Oswego, New York, and as a teenager worked as an errand boy for a local dentist, soon becoming a laboratory assistant. At 21, he moved to Boston, where he worked in a dental lab at the Harvard Dental School. He was invited to apply and graduated with distinction as one of only 12 students in the class of 1870. He was hired as a dental assistant at Harvard the following year. He became known for treating patients with cleft palates and held a patent for a device he called the oblate palate, which helped keep the palate in better alignment. In 1884, he was named to the Harvard dental faculty as an instructor in the treatment of cleft palate, becoming the first African American to serve on a dental school faculty. He later opened his own dental practice, and among his patients was Charles Eliot, Harvard's president.

Grant lived in Arlington Heights and built a small golf course on a meadow next to his home. Even after he and his family moved to Beacon Hill, Grant would return to Arlington to play golf.

The tee he invented received a patent and is described as having a rigid base with a flexible head. The base came to a point and could be inserted into the ground, while the tee itself was made of gutta-percha, a resin used in dentistry.

The tees were made in Arlington, but Grant never tried to sell them, instead giving them to friends. In 1991, the United States Golf Association recognized him for his contribution to the game. (Courtesy of the Countway Library of Medicine.)

Co-Founders

Robert "Bob" Frankston

VisiCalc, he first electronic spreadsheet, was created in 1979 by Bob Frankston and Dan Bricklin in the attic of Bob's Arlington apartment. It was specifically designed for use on personal computers and ran on the Apple II and later the IBM PC. It is credited with changing the way personal computers were used in business. Lotus now holds the copyright to VisiCalc. (Courtesy of Robert Frankston.)

Joseph C.R. Licklider

Joseph C.R. Licklider is sometimes called the Johnny Appleseed of computing. It was not his inventions but his ideas that earned him the honor of being named a pioneer in the Internet Hall of Fame, which cited him for describing features many have come to take for granted. These include graphical computing, user-friendly interfaces, digital libraries, e-commerce, online banking, and cloud computing. His 1968 paper explained that computers were not merely speedy calculators that made computing faster but could instead become networks for communication. He died at Symmes Hospital at the age of 75. (Photograph by Ben Shneiderman.)

Shadow the Cat

Nothing is known about the early life of Shadow, the town cat. Though his whereabouts can sometimes be elusive, he has been discovered exploring the stacks in the library or seeking supper at the senior center. Shadow appears to have an interest in politics, for he has been spotted in the balcony during town meetings and has attended at least one meeting of the Arlington Town Democratic Committee. Shadow's reputation is mixed. According to the official minutes of the council on aging from January 19, 2006, Shadow was banished from the senior center for being a nuisance. However, he keeps on returning. A poem written by Charles Schwab for the senior center newsletter in October 2008 provides a clue to Shadow's motivation. The third stanza reads: "Shadow the seniors' pet feline / For friendship everyone needs him. / So at lunch all make a bee-line / To be the one who feeds him." (Photograph by Nancy A. White.)

Hilary Putnam

Hilary Putnam is a major American philosopher whose work encompasses metaphysics, cognitive psychology, and the philosophy of science, language, and logic. He has also made contributions in the fields of mathematics and computer science and influenced virtually every major field of contemporary philosophy. In addition to teaching at Harvard, Putnam was known for his activism and was involved in the civil rights movement as well as the antiwar movement during the Vietnam era. He is the Cogan University professor emeritus at Harvard, and his wife, Ruth Anna, is professor emerita at Wellesley. (Courtesy of Hilary Putnam.)

Roy J. Glauber

Roy J. Glauber was awarded the Nobel Prize for physics in 2005 for contributions to the field of optics, which deals with the physical properties of light and its interactions with matter. Born in 1925, as a child he enjoyed reading Jules Verne and tried to build machines he saw in *Popular Mechanics* magazine. In high school, he built his own telescope and later a spectroscope, an instrument used to measure the properties of light. It won a New York City–wide science fair and was displayed at the 1939 New York World's Fair. He won a scholarship to Harvard and at age 18 was asked to join the Manhattan Project, which built the first nuclear bomb. He returned to Harvard and a teaching career. His work merged quantum physics with optics and helped describe the properties of light. (Authors' collection.)

RON RIVEST
FENWAY PARK
CEREMONIAL FIRST PITCH
APRIL 16, 2004

Ron Rivest

Online shoppers have Ron Rivest to thank. He and two colleagues developed the RSA algorithm, which allows credit card Internet transactions to be conducted privately and safely. Rivest's 1977 paper, written with Leonard Adelman and Adi Shamir, described the algorithm and won them the Turing Award, recognized as the highest distinction in computer science and sometimes called the Nobel Prize of computing. The algorithm was named for the developers' initials and is used in numerous private transactions, including medical records. Rivest is a professor at MIT and cowrote the textbook *Introduction to Algorithms*, which has sold more than 500,000 copies and is a classroom standard. He has also developed a protocol to keep votes safe and secure. Rivest has won numerous awards for his work, and one highlight was being chosen to throw out the ceremonial first pitch at a Red Sox–Yankees game in 2004. (Both, courtesy of Ron Rivest.)

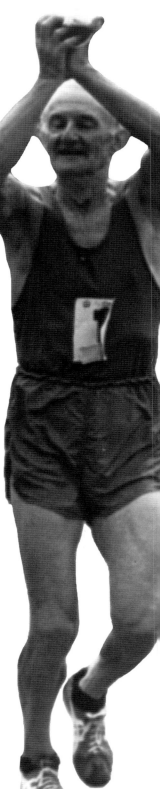

Johnny Kelley

Johnny Kelley ran the Boston Marathon a record 61 times, winning twice and placing second a record seven times. The oldest of 10 children, he had no money for college and spent 30 years working as a maintenance man for Boston Edison. He had to use vacation days to attend the 1936 Berlin Olympics and had no time off for training, so he ran early in the morning or late at night while working fulltime. He was chosen for Olympic teams three times. In 1993, a statue of Kelley was erected on the marathon course, and in 2000, *Runner's World* magazine named him Runner of the Century. His last full marathon was at age 84. He died at 97, a Boston sports hero. Considered a marathon legend, a statue of him presides over the marathon course near Heartbreak Hill. (Both, courtesy of the Arlington Historical Society.)

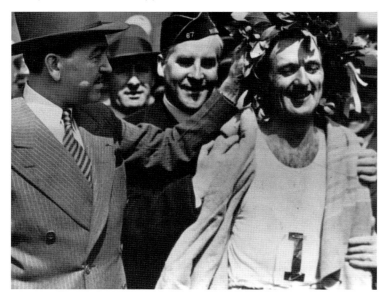

Bob Wilson

Bob Wilson's voice was known to thousands during his nearly 30-year career as the radio announcer for the Boston Bruins. He grew up in Arlington as Robert Castellon, graduating from Arlington High School in 1946. After landing a job at a Top-40 radio station he switched to his mother's maiden name after being told he needed a two-syllable last name to fit into the station's jingles. He joined WHDH in 1964 and in 1987 was awarded the Foster Hewitt Memorial Award for broadcasting excellence. He was known for his enthusiastic broadcasts as well as his resonant voice and sense of humor. In 2011, the Bruins named the broadcast booth at TD Garden in his honor. His successor, Dale Arnold, said Wilson had the greatest voice in the history of NHL broadcasting. (Courtesy of Nancy Castellon.)

Tom McNeeley

Tom McNeeley (right), a heavyweight with a 37-14 record, became famous for one of the fights he lost. In 1961, he fought Floyd Patterson for the heavyweight championship and lost in four rounds after being knocked down nine times. A self-deprecating man, he told the *Boston Globe*, "The stories about the fight said I went down 9 or 10 times. The writers were being nice to me. . . . It was more like 12 or 13." After his boxing career ended, he served as Massachusetts State Boxing Commissioner. His father, also named Tom McNeeley, was the light heavyweight champion of New England. (Authors' collection.)

Mark J. Sullivan

In 2006, Pres. George W. Bush appointed Mark Sullivan director of the Secret Service. Sullivan had already worked for this agency for 23 years and won numerous awards. By the time he retired in 2013, Sullivan had protected five presidents and thousands of heads of states and had provided security for two presidential campaigns and 22 national events. (Courtesy of Mark J. Sullivan.)

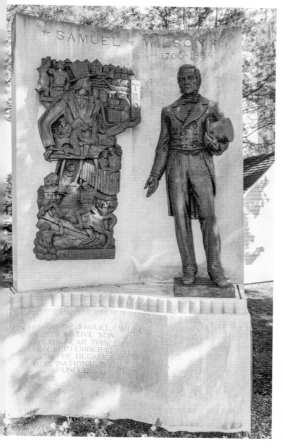

Uncle Sam (1766–1854)

Yes, Uncle Sam was real. He was born Samuel Wilson in Arlington and started a meatpacking business in Troy, New York. During the War of 1812, he was a meat inspector for the government. Boxes of beef and lamb arrived for our troops stamped "US," denoting United States. Soldiers jokingly referred to their food as coming from Uncle Sam. Thus, Uncle Sam became the nickname for the US government.

Samuel Wilson was clean shaven. Cartoonists added the beard and the red-white-and-blue hat and pants. In 1916, James Montgomery Flagg created the famous recruitment poster that had Uncle Sam's likeness. During World War II, a German intelligence agency used Samland as a code name for the United States. A statue of a young and beardless Uncle Sam now stands in Arlington Center. Pictured at right is a 1917 World War I recruitment poster. (Left, photograph by Joey Walker; right, courtesy of the Library of Congress.)

Susan Shaer

For more than 40 years, Susan Shaer has been involved in politics and progressive movements, consulting with candidates and encouraging women to run for office. Since 1993, she has been the executive director of WAND (Women's Action for New Directions), a national peace and security organization that has its national office in Arlington. WAND's goal is to educate the public and opinion leaders about the need to reduce violence and militarism and to redirect excessive military spending to unmet human and environmental needs. Shaer also founded and cochairs Win Without War and founded the Pentagon Budget Campaign, an effort to cut wasteful Pentagon spending. She chaired Project Abolition, as well as other national projects on arms control and disarmament. Shaer was awarded the OMB Watch Public Interest Hall of Fame Award, the National Priorities Project Frances Crowe Award, the National Priorities Project Hero Award, and the New England Women in Cable Award for Outstanding Moderator for her cable public-affairs television program, *The Front Page*. Shaer cofounded the Massachusetts Budget and Policy Center and was a leader in the winning effort to sue the state government to equalize education spending. (Photograph by Barbara C. Goodman.)

Tom and Ray Magliozzi (Click and Clack the Tappet Brothers)

In 1973, Tom (right above), a dropout from the corporate world, and Ray (left above), a former science teacher, started Hackers Haven, a do-it-yourself garage in Cambridge, Massachusetts. Even though this business failed, by 1977 they had their own National Public Radio program called *Car Talk*. This call-in show that focused on car repair won a Peabody award, aired on 600 stations, and had a following of four million listeners. They also ran the Good News Garage.

Tom and Ray were master mechanics with degrees from MIT. They were also hilarious. Cars were just an excuse for having fun, wisecracking, and self-deprecating humor. They gave out trustworthy advice about cars but also pontificated about life, relationships, and doing the right thing. The show ended in 2012 after a 35-year run. Tom died two years later. (Photographs by Richard Howard, courtesy of *Car Talk*.)

INDEX

INDEX

LEGENDARY LOCALS

AN IMPRINT OF ARCADIA PUBLISHING

Find more books like this at
www.legendarylocals.com

Discover more local and regional history books at
www.arcadiapublishing.com

Consistent with our mission to preserve history on a local
level, this book was printed in South Carolina on American-
made paper and manufactured entirely in the United States.
Products carrying the accredited Forest Stewardship Council
(FSC) label are printed on 100 percent FSC-certified paper.